More from
THE TEXTILE ARTIST series

Layered Cloth
978-1-78221-334-5

Small Art Quilts
978-1-78221-450-2

Layer, Paint and Stitch
978-1-78221-074-0

Expressive Stitches
978-1-78221-750-3

The Seasons in Silk Ribbon Embroidery
978-1-78221-655-1

Appliqué Art
978-1-84448-868-1

Sculptural Textile Art

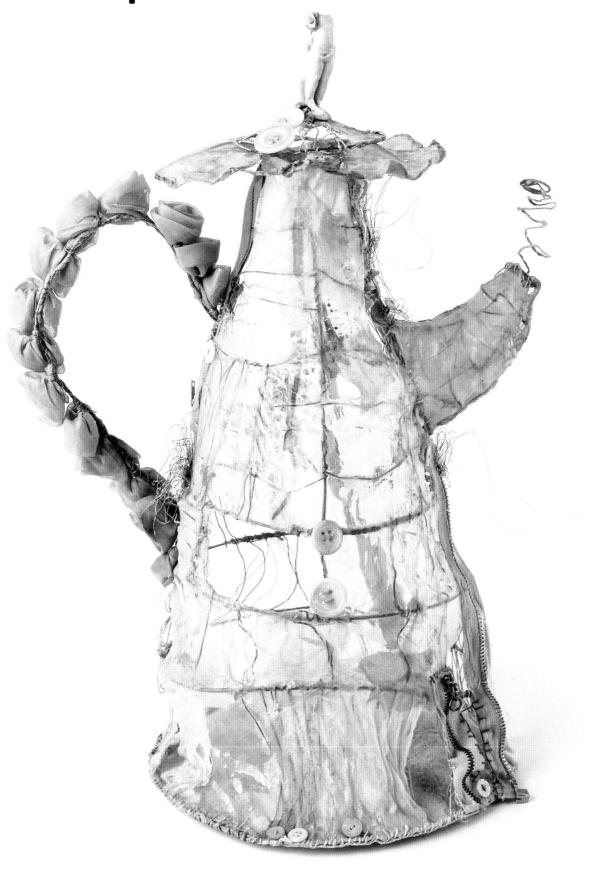

DEDICATION

This book is dedicated to my husband
Phil and my family, for their constant
support and encouragement on my
creative journey.

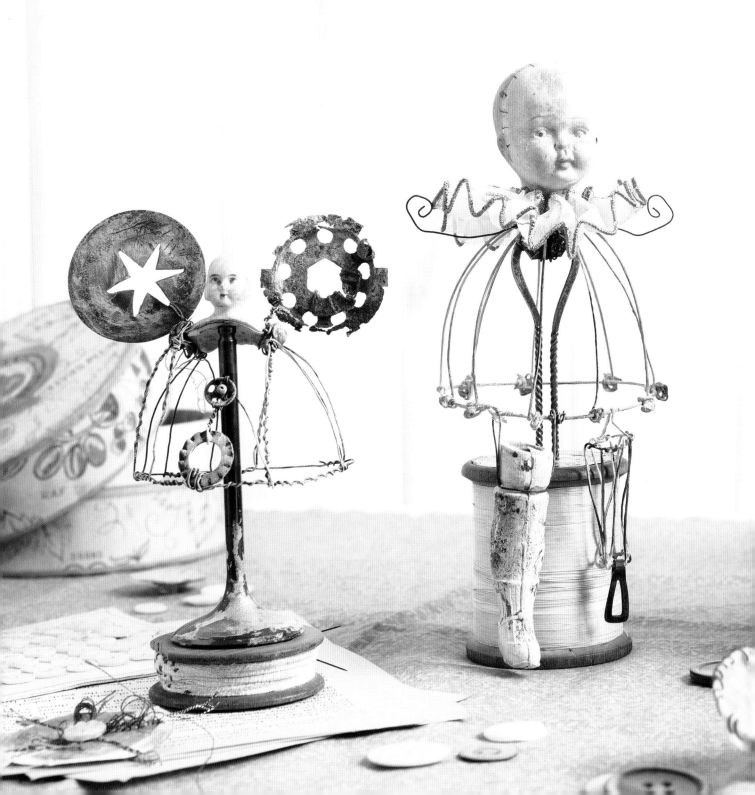

Sculptural Textile Art
A practical guide to mixed media wire sculpture

Priscilla Edwards

SEARCH PRESS

First published in Great Britain 2022

Search Press Limited
Wellwood, North Farm Road,
Tunbridge Wells, Kent TN2 3DR

Illustrations, templates and text copyright © Priscilla Edwards, 2022

Photographs by Mark Davison at Search Press Studios, except for pages 2–3, 27, 29, 39, 40, 43, 47, 55, 61, 63, 71, 92–93 (main image), 94, 114, 115, 127, by Stacy Grant, and page 126, by Prue Edwards.

Photographs and design copyright © Search Press Ltd. 2022

ISBN: 978-1-78221-900-2
ebook ISBN: 978-1-78126-904-6

Suppliers
If you have difficulty in obtaining any of the materials and equipment mentioned in this book, then please visit the Search Press website for details of suppliers:
www.searchpress.com

Extra copies of the templates are available from
www.bookmarkedhub.com

You are invited to visit the author's website:
www.priscillaedwards.co.uk

ACKNOWLEDGEMENTS

I would like to thank Roz Dace for asking me to create this book and my editor, Edward Ralph, for his encouragement and guidance.

My thanks to Mark Davidson, Stacy Grant and Prue Edwards for their truly stunning photography, bringing my work to life through their amazing photographic and styling skills.

A huge thank you to my Mum who taught me to sew and for sharing her love of all things unusual.

A special thank you my dearest Popa who taught me to embroider.

Thank you, Auntie Alice, for giving me so much including your love of all things textile; bless you for your drawers full of wonderful treasures.

My thanks to Sally E. Payne who has been the most marvellous mentor and tutor, who has taught and encouraged me since I was seventeen, and continues to teach me new things all the time. I can never thank you enough for all the years of support for my practice.

My thanks to my tutor Judy Barry who, at university, was always reminding me 'you *can* make a silk purse out of a sow's ear', something I remember every day!

My thanks to my dear friends Helen Belbin, Nicki Smith and Christine Stanford for all their words of encouragement while creating this book.

Many thanks to Dawn Boulton on her eye for detail and thrashing out ideas.

I'd also like to thank all the creative students I've had the pleasure of working with over the last twenty years – you have been an inspiration!

Page 1
Polly Put the Kettle On
34 x 45cm (13¹/₂ x 17³/₄in)

Pages 2–3

Left to right:
Lost and Found
9 x 13cm (3¹/₂ x 5in)

Charlotte
7 x 17cm (2³/₄ x 6³/₄in)

Cream Jug
12 x 17cm (4³/₄ x 6³/₄in)
Souvenir Spoon
4 x 28cm (1¹/₂ x 11in)

Opposite
Time for Tea!
18 x 13cm (7 x 5in)

Contents

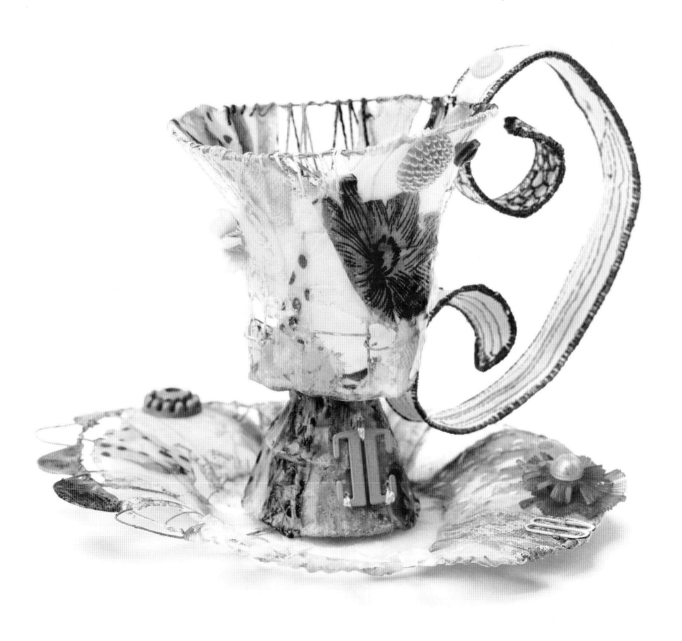

Introduction

There can be a variety of beginnings in any creative journey – perhaps an idea strikes you, or you want to experiment with a new material. Each one of us starts in a different place and there are no right or wrong ways; just the way that works for you. My aim is for this book to reveal a new beginning for you, and perhaps show you how to develop your work in a new way or to try something a little different.

I love working in three dimensions and, while completing my degree in Embroidery, I discovered that working with wire in this way proved to be a natural path to bring my ideas together. Tackling the complexities of making textiles into something sculptural can sound intimidating, but I encourage you to give it a go. It is both challenging and hugely satisfying at the same time, making it a special and unique way of working.

I have filled this book with a variety of my ideas, techniques and processes, and how I combine them. It is a little window into the way I work. Each piece is made from a basic wire structure, created using a combination of pliers and hand manipulation to form a shape. Personal interpretation is key to the process, so your pieces will have your signature woven into their very core. It's an organic way of working that unlocks a wealth of exciting possibilities, so be open to the structure developing in ways that may be unexpected.

I hope the ideas in this book will inspire you to discover the joy of making sculptural textiles for yourself. The fun of collecting found materials and the thrill of fusing these elements together is quite addictive. There are no limits to this fascinating process and you can let you imagination take your ideas in any direction. The journey is organic, so I urge you to embrace the ebb and flow of the making as you progress with a piece and listen to what it is saying to you. I've loved creating all the step-by-step projects for you to try, and I hope you enjoy having a go. Again, there is no right or wrong way to do anything – just be yourself and always trust your instincts!

Priscilla Edwards

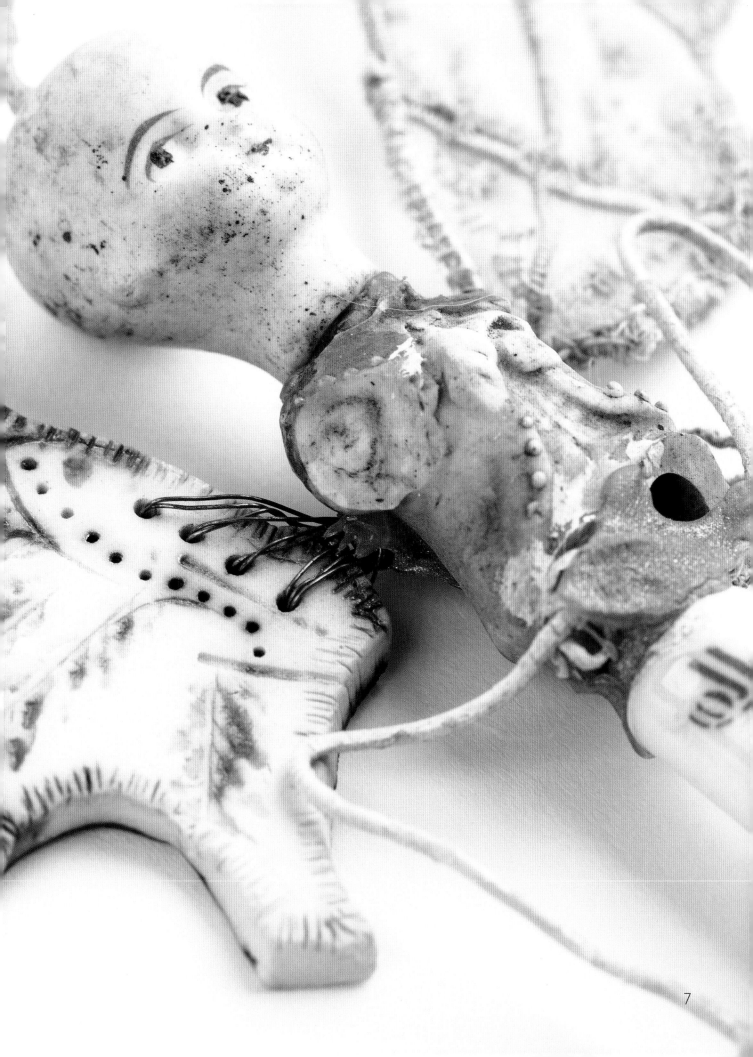

Materials and equipment

You don't need lots of specialist equipment to create the projects in this book, much of what is needed you will have in your art and textile supplies. All of the pieces are created in three broad stages. First you make the wire structure, then add the fabric and wax, and finally you embellish the piece. These stages require a few simple tools, but nothing too outlandish.

I like to work with lots of different materials and firmly believe in using every scrap and fragment in my stash. Start to build your own collection by regularly checking out the local charity and thrift shops, car boot sales and jumble sales for materials. This way you can pick up really inexpensive fabrics and haberdashery, sourcing lots of unique items that have their own patina and are just perfect for creating something that's personal to you.

Wire

Wire is measured by gauge. The lower the gauge number, the thicker the wire. I use 20–28 gauge, white paper-covered wire because it's not so harsh as working with a non-covered wire. The covering has a really nice feel to it when manipulating with your fingers, making working with it a pleasure. I frequently add paint to parts of my structures with acrylics and I find the paper takes these paints well; it also absorbs hot wax helping to bond added fabrics.

Another reason I find this product so useful is that it is available in convenient packs of 36cm (14in) lengths of wire in a variety of gauges. I tend to use 24 and 26 gauge most of the time, and it is these two gauges we will be using for the projects later on in the book. Occasionally I supplement the paper-covered wire with a coil of 24 gauge black iron wire when I need to create a strong contrast in a piece of work. This is more of an aesthetic choice than a practical one to achieve a different look.

Coil of iron wire.

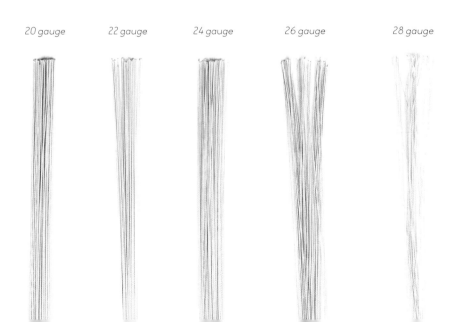

20 gauge 22 gauge 24 gauge 26 gauge 28 gauge

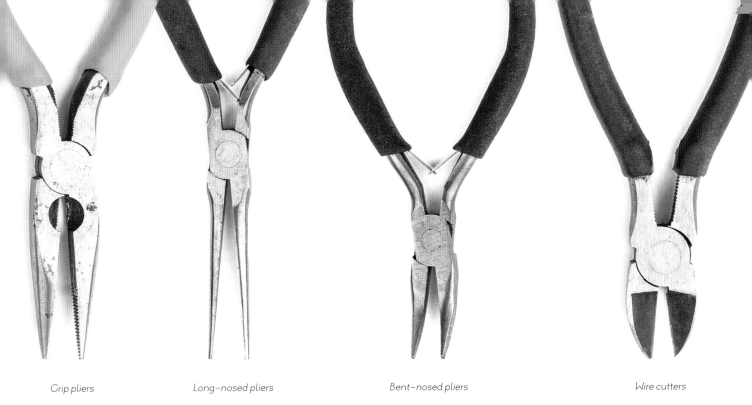

Grip pliers *Long-nosed pliers* *Bent-nosed pliers* *Wire cutters*

Pliers and wire cutters

Grip pliers Known as 'grip pliers' throughout this book to distinguish them from the other, more specialized types below, these familiar household pliers are really useful for shaping your structures and can take the pressure off your fingers when doing fiddly joins and finishing off ends.

Long-nosed pliers Also called needle-nosed pliers, these have longer, thinner jaws than grip pliers. This makes them wonderful for getting into those hard-to-reach areas that your grip pliers are not quite able to access.

Bent-nosed pliers These have angled jaws that can be really useful if you have to make adjustments at a tricky angle that's hard to reach.

Wire cutters Always cut your wire with a pair of wire cutters. Don't be tempted to use household scissors, as it will quickly blunt the blades – or worse, cause a burr that will ruin the scissors completely.

Fabrics

My fabric collection is vast and encompasses a huge variety of different qualities, contrasts in weight, texture, pattern and colour. Most of my work is made up of vintage fabrics; I love the weathered qualities of a fabric that has been loved and worn over many years. Old materials come with such history, and by reworking them I hope to communicate some of their story and reveal traces of the original owner. Who knows what stories they could tell – oh, if only they could speak!

Silk habotai This is a lovely fabric to work with. It has a tightly woven structure and is less likely to fray than other types of silk. It also has a handsome sheen and will take dye beautifully. Habotai comes in different weights – opt for a lightweight habotai, as this is easier to sculpt over a surface.

Chiffon A very sheer silk with a matt finish, chiffon is very translucent. It has a beautiful weightless feathery texture and frays and tears easily. I tend to buy this new and undyed, as it's such a fragile cloth that few vintage pieces survive.

Georgette A little more heavyweight than chiffon, georgette is more a robust sheer fabric. You can often find vintage scarves in soft colours made from this fabric.

Lightweight cotton is a lovely alternative to silk particularly if you are vegan. Muslin or cotton lawn work well and vintage dresses were often made using this type of cotton. Look out for Liberty prints when sourcing materials, as their dainty prints are fabulous.

Vintage silk scarves and dresses I love worn silk. It is just delicious to work with – silk scarves especially, because of the range of different printed patterns you can find. Keep your eyes peeled for floral prints, souvenir prints or conversational prints (those with fun objects, animals or other things printed on them), as these can make wonderful motifs to add to your sculptures.

TIP

Adding wax to fabric will make it a tone or two darker, so it's generally a good idea to choose slightly more vivid and vibrant colours than you want in your textile artwork. Using already deep colours like navy blue, maroon and black can result in moodier, darker finished pieces.

Just a glimpse into my fabric stash!

Printed fabrics

I use lots of printed fabrics and opt for subtle colours with hints of stronger tones, as this leaves enough scope to highlight areas with stitching later on.

When selecting your fabrics, check the labels to make sure they are made from natural fibres. If the fabric is synthetic or a mixture of fibres it can make it more difficult to work with because the synthetic fibres can resist the hot wax when you apply it.

If you are lucky enough to find patterned silk dresses or scarves, make the most of any decoration when cutting up the fabric: you can isolate details of decorative print or even stitching. Also look out for zips, buttonholes, darning, appliqué, and seams – these are often overlooked but can make lovely additional surface qualities to your work.

Kid leather

Kid leather Is a great material to use that contrasts so well with the lightweight silks. Leather naturally has a smooth side and a textured suede side, and that's a lovely contrast in itself.

Buying leather can be pricey but by sourcing old opera gloves you can get smaller quantities of leather without breaking the bank. These gloves usually come in white or soft sherbet colours, and if they have been well used the leather will have a lovey patina. I particularly like to use leather to make cup and teapot handles because the material remains quite rigid and will retain its shape.

If you struggle to find second-hand opera gloves, you can always use faux leather of a similar weight; a heavy calico will also work just as well.

Lace

I mentioned earlier that contrasts in textures are as important as colour and fabric weight, and lacy trim is a great way to add textures and surface to a piece of work.

I collect lace lengths in different widths and often cut them into thinner strips as they can be woven into wire structures really easily.

You can save lace edgings from vintage dresses, blouses and old table runners. Every little fragment can be repurposed!

Embroidery materials

The essential piece of equipment here is a **sewing machine** that you can use to create free machine embroidery. Most modern sewing machines adapt to using free machine embroidery so you won't have to invest in a fancy new one!

The rest of the materials needed are things you may already have in your sewing kit. If you don't then they make really useful additions that can be used in lots of different ways for a variety of projects.

Free machine embroidery foot You will need to replace the universal straight stitch or presser foot that comes as standard with your sewing machine with a free machine embroidery foot, also known as a darning foot. They are usually quite easy to get hold of; just make sure it will fit the model of your machine. I use an open darning foot for my free machine embroidery as it enables me to see the detail in my stitching more clearly. A closed foot works just as well – it's really down to personal preference. If you can't get a free embroidery foot to fit your sewing machine, you can use a spring needle. This allows you to free stitch without using a foot at all.

Hand embroidery threads I use a broad variety of threads in my work and try to collect vintage threads where possible. I like to use fine twisted rayon crochet threads as they catch the light beautifully. I also use silk and linen vintage thread for hand-stitched embellishments.

Stranded embroidery threads in assorted colours Anchor stranded embroidery threads are fabulous - these can be separated into several strands to create a more delicate stitch and come in such a huge variety of colours – see page 48 for more details.

Machine threads Madeira rayon threads come in four different thicknesses and a mouth-watering range of colours. Rayon threads are wonderful – they catch the light and shimmer so beautifully particularly when used with a satin stitch. I like to use No. 40 for stitched projects that need a more delicate approach and No. 30 when slightly thicker thread is required.

Needles Try to use steel hand sewing needles – vintage where possible, because these are the best quality. Always select the appropriate needle with the correct eye size for the thread you wish to use: there will be a guide on the packaging.

Machine needles Always use good quality needles on your sewing machine, Schmetz embroidery needles sizes 75 (US 11) and 90 (US 14) are excellent – these are designed to work perfectly with rayon threads of different weights. To achieve beautiful embroidered stitches the size of your needle is vital and should also match the weight of fabric you are using.

Embroidery hoop frames These are essential when stitching freehand with a darning foot on your sewing machine, as they will eliminate wrinkles and puckering as you sew. Buy a wooden or metal hoop with a screw fitting. Always make sure your cloth is stretched tightly across the hoop before you begin, ensuring the cloth is as tight as a drum. Having a couple of different sized hoops can be useful, particularly if you have a very small piece of fabric you want to embroider on.

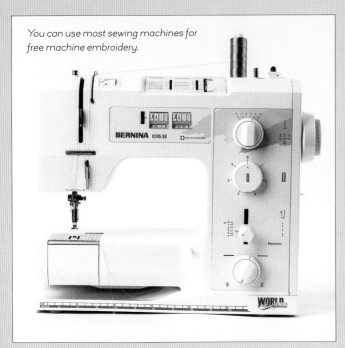

You can use most sewing machines for free machine embroidery.

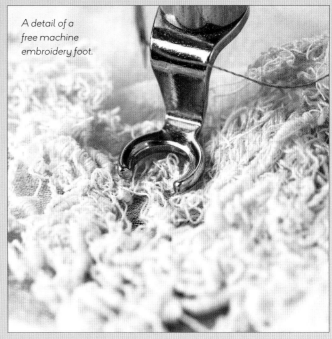

A detail of a free machine embroidery foot.

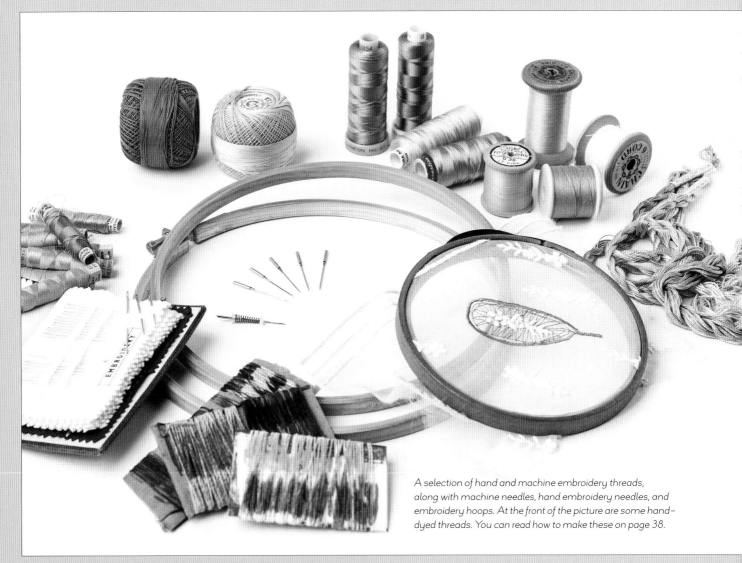

A selection of hand and machine embroidery threads, along with machine needles, hand embroidery needles, and embroidery hoops. At the front of the picture are some hand-dyed threads. You can read how to make these on page 38.

Batik wax, batik pot and brushes

My art tutor introduced me to the wonders of batik when I was just sixteen years old, studying for my art diploma. I was totally bewitched by the effects of the wax on fabric and have been obsessed with this seductive material ever since.

When making sculptural work I apply the hot wax over lightweight silk – when the two come together the wax alters the silk's surface making it translucent. The transformation is more apparent when you use the wax on a patterned fabric: hold it up to a light and you will see it becomes almost like stained glass – beautiful!

Batik pot I use a Tixor Malam Batik Pot for textile artists with a temperature that's controllable up to 135°C (275°F). It's a great tool as it allows you to melt up to 300ml (½pt/12 fl oz) of wax, yet it is shallow enough to rest a brush in without the handles getting coated in wax. The adjustable temperature is great for melting wax at a lower temperature than would be used in traditional batik.

Batik wax pellets This type of wax is a mixture of beeswax and paraffin wax. The blend of wax works really well because the beeswax softens the paraffin wax, making it less brittle once it has cooled.

Old paintbrushes Use old paintbrushes to apply the hot wax, because once a brush has been dipped in hot wax it is impossible to remove. The brush can be re-immersed in the wax and reused over and over again, I've been using the same brush for years. I recommend using a 12mm (½in) decorator's brush. This size works really well and can hold just the right amount of wax. Make sure you keep the brush immersed in the wax when you are in-between applications; only remove it completely when you have finished.

Protective mat Always use a few sheets of newspaper or a mat when working with the hot wax to protect your surface.

TIP

If you don't want to invest in batik wax pot, you can use a slow cooker as an alternative. They can be picked up quite inexpensively from a supermarket or thrift shop. They work well for batik as you can adjust the temperature in the same way as a traditional wax pot. Just don't use it to cook with once it's been used with wax!

SAFETY

Heated wax can be very dangerous if not handled carefully. Avoid dripping hot wax on your skin by always brushing the wax away from you when you are applying it to a surface. Keep fingers away from the metal edging of the batik pot and make sure your keep the pot away from edges of tables, tucking the power cable away from exposed areas. Finally, always switch off and unplug the pot when it is not in use.

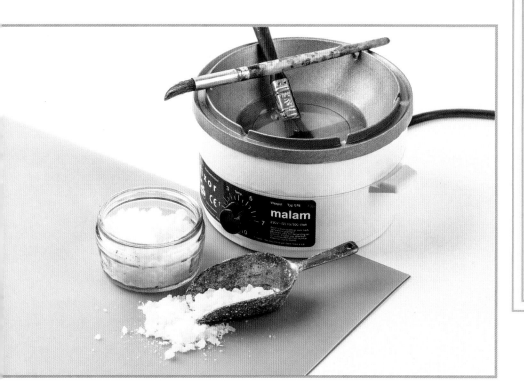

Paint and paintbrushes

I paint my sculptural wire structures to highlight certain areas. This is for several reasons. Firstly, it enables me to draw a focus to a particular part of a piece of work and can also provide contrast against the fabric colours I have already used. Secondly, I sometimes use paints as a way to blend one fabric into another or emphasize a textural area.

Acrylic paints These are really versatile. You can apply them to almost any surface and they can easily be let down with water where needed. They are also great for mixing to create your desired colour palette and air dry really quickly.

Inks Acrylic inks can be used neat or mixed with acrylic paints. They can also be watered down and make a great alternative to dyes if you want to change the colour of a small amount of thread or fabric. I also use Quink ink, a calligraphic ink with interesting properties when wetted.

Matt emulsion paints These can be bought in small tester pots from your local decorating store, and are an inexpensive alternative to buying acrylic paint. They mix well with ink and provide a nice chalky finish to a piece of work.

Paintbrushes Use brushes suitable for use with acrylic paints and inks. Have a few different sizes to hand, and ensure a couple have long handles: these are useful when applying paint to surfaces that are hard to reach.

Palette A paint palette is really useful for mixing different colours together so you achieve exactly the right shade. You can use an old plate or buy an artist palette that has moulded wells for holding paints.

Water pot Use a water pot to rinse your brushes regularly when you are using paint and inks. When you have finished, make sure to wash your brushes more thoroughly with some warm water and soap to ensure that all traces of pigment are removed.

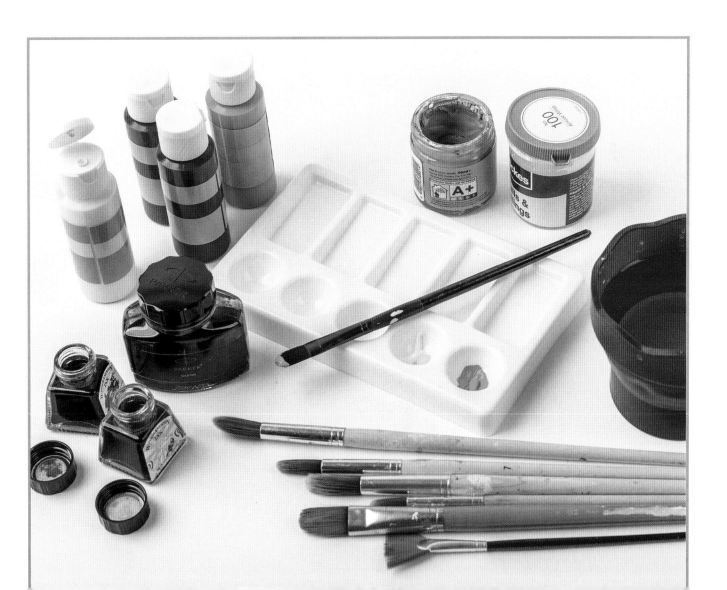

Embellishments

You can embellish your work with stitching, or with the addition of other materials such as buttons, beads, broken jewellery and found objects.

Found objects regularly feature in my work and I often make a piece to include a specific item I have found fascinating or inspirational. You'll find examples through the book where I have used things such as a piece of broken porcelain, a worn-out suspender clip or a distressed vintage buckle that I've picked up at a charity shop or car-boot sale.

Far from finishing touches, these embellishments form a core part of the completed pieces as they are entwined and stitched into your work. These additions add to the narrative of your piece, bringing it alive and making it personal and unique to you.

By their nature, embellishments can take many forms. Having some sort of organization – even as simple as keeping like with like in small boxes – is useful to ensure you can find what you need when you need it.

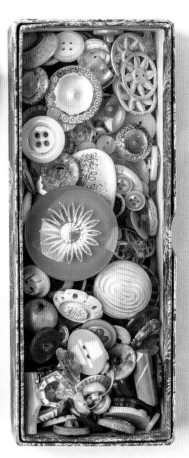

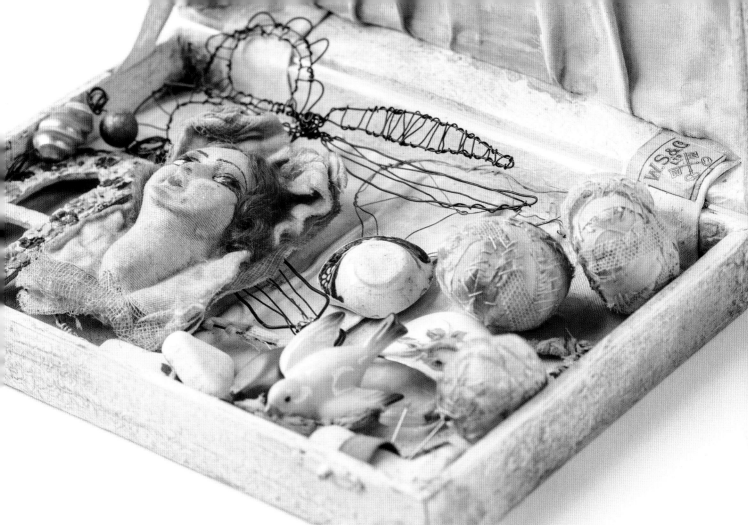

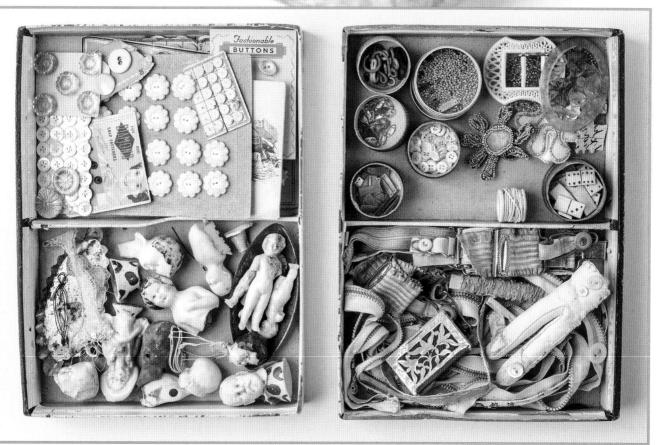

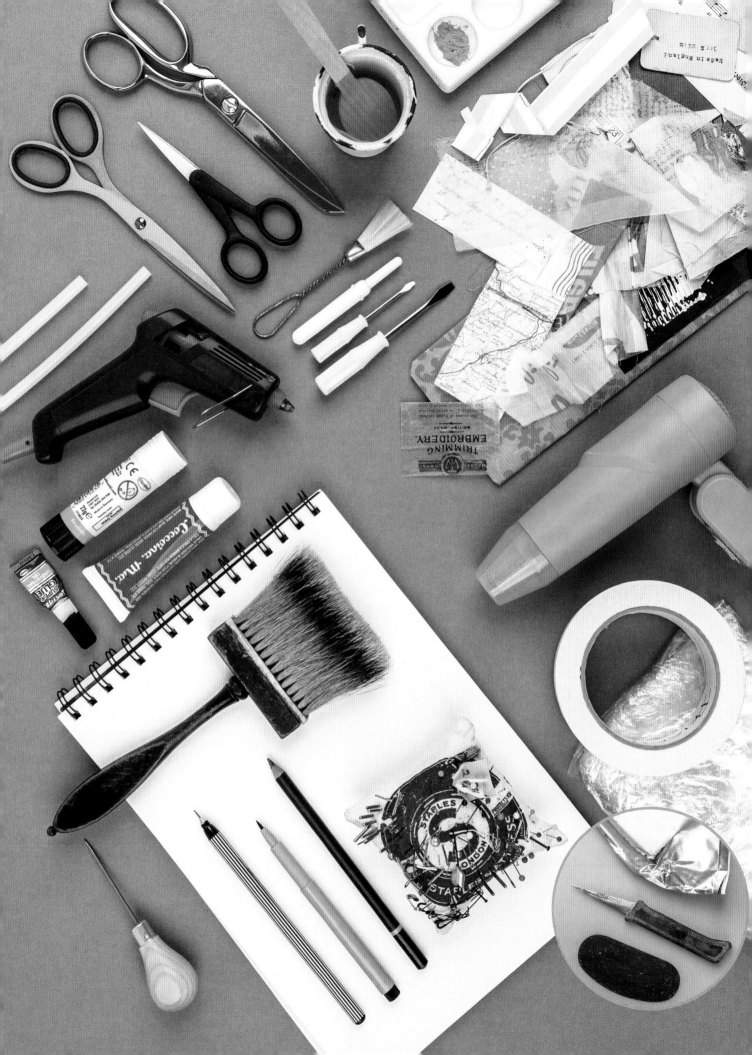

Additional materials

Scissors Have a pair of fabric scissors and a pair of sharp pointed embroidery scissors for trimming threads. Keep a separate pair for cutting paper as this can blunt blades.

Glue Superglue is used for securing small items to your sculptures when it isn't possible to stitch them in place. PVA glue can be watered down and used with a paintbrush to attach paper to three-dimensional pieces. A glue stick is handy to add collage to your sketchbook.

Hot-glue gun When you need to secure a larger object to a sculpture and it not possible to hand stitch the item in place – for example, attaching a china doll head to a wire structure – hot glue will work perfectly.

Heat tool This can be useful to melt away areas of over-waxed fabric. You can also use a heat tool to re-melt layers of fabric that have been waxed if you wish to remove them.

Clay, knife and kidney Air-drying clay is a great product to make a base for small sculptures. Once dry, you can use PVA glue to attach papers and ephemera, or paint it with acrylics. To cut the clay, use a sharp knife and a metal or plastic kidney to smooth out edges.

Dye, mixing pot and stirrer When making up a small amount of cold water powder dye, use a glass or enamel mixing pot as these won't stain. Use a teaspoon to measure the dye quantities following the manufacturer's instructions.

Pins and pincushion Glass-headed dressmaking pins are best as these do not melt if they accidentally get a blast of heat from the heat tool, and they are easy to find if they get trapped between layers of waxed silk. Use a pincushion to keep your workspace tidy.

Dissolvable fabric Aquafilm is a water-soluble stabilizer you can free stitch your designs onto. When complete the film can be washed away using cold water. This product is transparent so ideal for tracing designs onto before you start to sew. It can also be doubled up to make an extra strong base for concentrated areas of stitch.

Gold bronzing powder This can be used to highlight textures on your sculptures. It works particularly well on lace or embroidered surfaces.

Large soft brush When trimming threads, keep a large soft brush handy to sweep offcuts into the bin, keeping your workspace nice and clean. You can also use it to brush off fragments of excess brittle wax on your sculptures.

Awl This is used to make holes in wet clay so that wire ends have a recess to be glued into once the clay has had a chance to air dry. An awl is also useful for making small holes in a waxed surface in case you have to add extra pieces of wire to a sculptural piece. If you don't have an awl you can use a large, sharp embroidery needle instead.

Masking tape Low-tack masking tape is useful for temporarily holding wire, paper or fabric in place when a pin is not suitable. Masking tape is also great for holding photographs and cuttings in place in your sketchbook if you don't want to glue them in.

Cartridge paper Use a sheet of white cartridge paper underneath you while working. This provides you with a clean neutral background to work on, making it easier to see what you are doing. It's never a good idea to work on a coloured or patterned surface as this can be distracting.

Sketchbook Sketchbooks are useful to put your ideas down on paper and a place to experiment.

Pens and pencils Used for sketching, my favourites are watercolour pencils, pens and crayons. I also use watercolour brush pens and non-permanent fine liner pens. All of these can be used with water to create washes.

Scrap paper I collage these into sketchbooks with my drawings and use these papers in finished pieces of work – perhaps to add an extra touch to a finished sculpture. You can use anything, from old maps and sweet wrappers to vintage letters bought at a flea market. All have their own wonderfully rich surface quality and weight.

Vegan materials

If you are vegan or don't feel comfortable using animal-based materials then you can use lightweight natural fabrics, such as cotton lawn or muslin, as an alternative to silk. You can also use soya wax as a replacement for batik wax, which contains a percentage of beeswax.

Inspiration

It's a cool misty Sunday morning, about 6am. The shrill ring of an alarm clock next to your bed awakes you abruptly from your pleasant slumber. You are blinking and thinking ruefully that it's really too early to be up at this hour on a weekend – then you suddenly see in your mind's eye a large green field, or perhaps a car park. The vision is brimming with the possibility of intriguing discoveries beyond your wildest dreams – have you guessed it? Yes, it all starts with a car boot or yard sale!

Sources of inspiration, however, can come from anywhere: museum or gallery visits and trips to gardens and places of interest are all great starting points when searching for subject matter. I also use film, theatre, literature, poetry and folk stories as inspiration as I enjoy collecting stories; it's very important that my work has a strong narrative.

I also have a huge postcard collection and lots of scrapbooks with magazine cuttings that I flip through for ideas – great when you get stuck and just need a blast of inspiration. Websites like Pinterest and Instagram are also fantastic ways to gather ideas.

Starting points

For me, the materials I work with are the real beginning for any new piece of work. I resource a lot of my materials from vintage shops, thrift stores, charity finds and second-hand sales. I look for two types of things at a sale. The first is interesting materials from which I can make a sculptural piece; the second is things that inspire me to create new work.

I'm always on the look out for the odd and unusual to add to my ever-growing collection of objects and ephemera. These finds can be anything from a scrap of interesting paper to a faded fabric tape measure. I have no specific criteria;

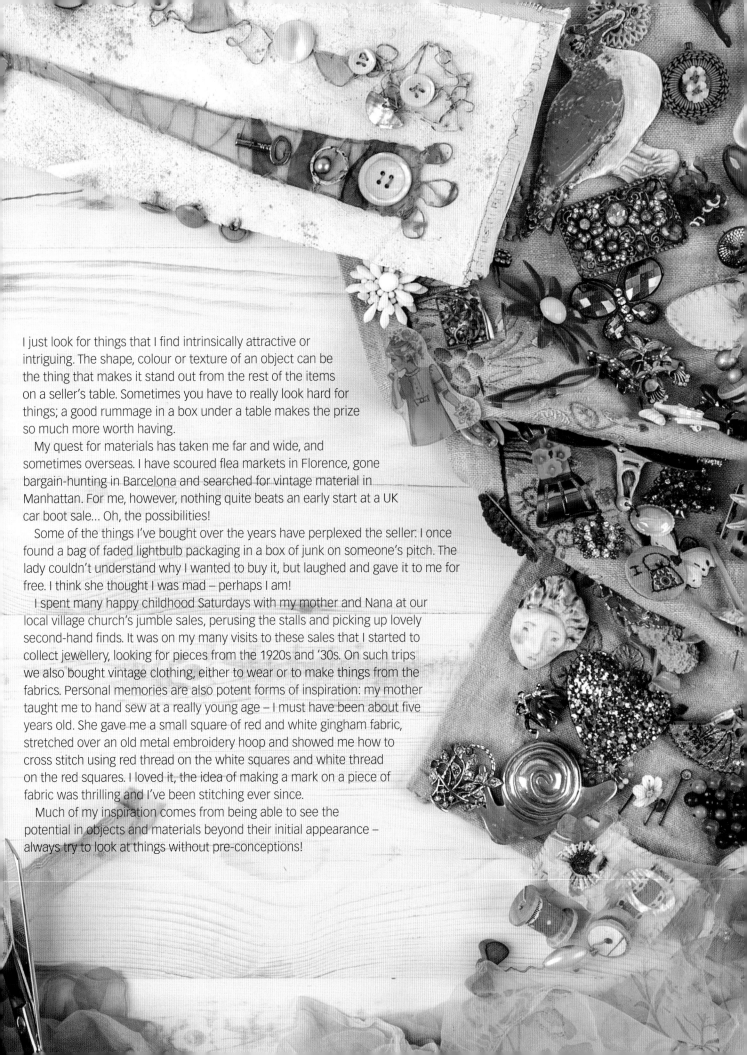

I just look for things that I find intrinsically attractive or intriguing. The shape, colour or texture of an object can be the thing that makes it stand out from the rest of the items on a seller's table. Sometimes you have to really look hard for things; a good rummage in a box under a table makes the prize so much more worth having.

My quest for materials has taken me far and wide, and sometimes overseas. I have scoured flea markets in Florence, gone bargain-hunting in Barcelona and searched for vintage material in Manhattan. For me, however, nothing quite beats an early start at a UK car boot sale... Oh, the possibilities!

Some of the things I've bought over the years have perplexed the seller: I once found a bag of faded lightbulb packaging in a box of junk on someone's pitch. The lady couldn't understand why I wanted to buy it, but laughed and gave it to me for free. I think she thought I was mad – perhaps I am!

I spent many happy childhood Saturdays with my mother and Nana at our local village church's jumble sales, perusing the stalls and picking up lovely second-hand finds. It was on my many visits to these sales that I started to collect jewellery, looking for pieces from the 1920s and '30s. On such trips we also bought vintage clothing, either to wear or to make things from the fabrics. Personal memories are also potent forms of inspiration: my mother taught me to hand sew at a really young age – I must have been about five years old. She gave me a small square of red and white gingham fabric, stretched over an old metal embroidery hoop and showed me how to cross stitch using red thread on the white squares and white thread on the red squares. I loved it, the idea of making a mark on a piece of fabric was thrilling and I've been stitching ever since.

Much of my inspiration comes from being able to see the potential in objects and materials beyond their initial appearance – always try to look at things without pre-conceptions!

Developing your ideas

Recording your ideas

Sketchbooks are a wonderful tool for helping to develop and refine your ideas, and I encourage you always to have one with you – you never know when you will see something amazing and need to make a note or do a quick sketch. I love drawing and find working through my ideas in a sketchbook really useful. They allow me to explore an idea before it even gets to the sampling stage (see below), providing me with a reference point to work from when I do begin to experiment.

Not everyone feels comfortable working in sketchbooks and that's fine. The vital thing is that you record your ideas somewhere, so drawing and making notes are the most important thing. If sketchbooks don't work for you, try using separate sheets of paper and keep them in a binder or box, or rely more heavily on written notes and photographs. Find a way that works for you – there is no right or wrong.

Sampling

Before embarking on any new idea, it's vital to experiment and spend some time sampling and becoming familiar with your materials. Make a start by putting all your materials out on a neutral surface – a large sheet of white cartridge paper is perfect for this. I suggest you group together various materials – threads, fabrics, ephemera and found objects – and use your camera phone to take snapshots to record these groups. Next, play with moving elements of the collections around, swapping them from one group to another. With the knowledge that you can refer to the pictures on your phone if you want to go back to a previous grouping, you've got the opportunity to experiment freely.

Doing the process described above will help you to create a collection with a harmonized colour palette, and also provides you with the opportunity to see how different materials work together. Don't forget to consider contrast, as this is really important and can easily get overlooked – it's a key part of any successful project.

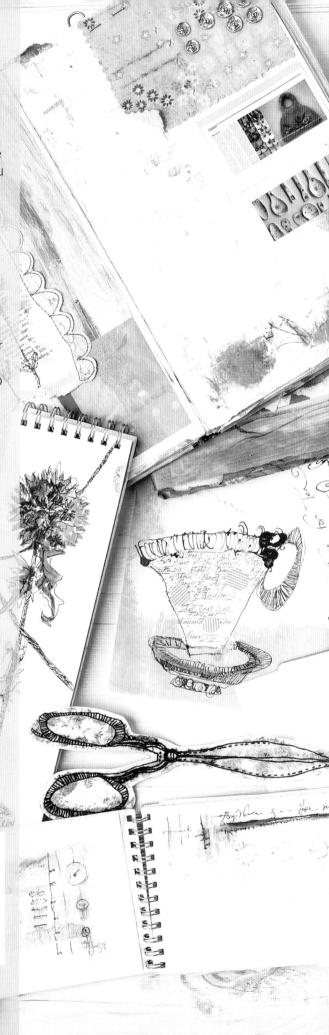

TIP

It's good to have a variety of sketchbook sizes. You can pop a small one in your bag or pocket so that you always have one with you to jot down an idea or do a quick sketch.

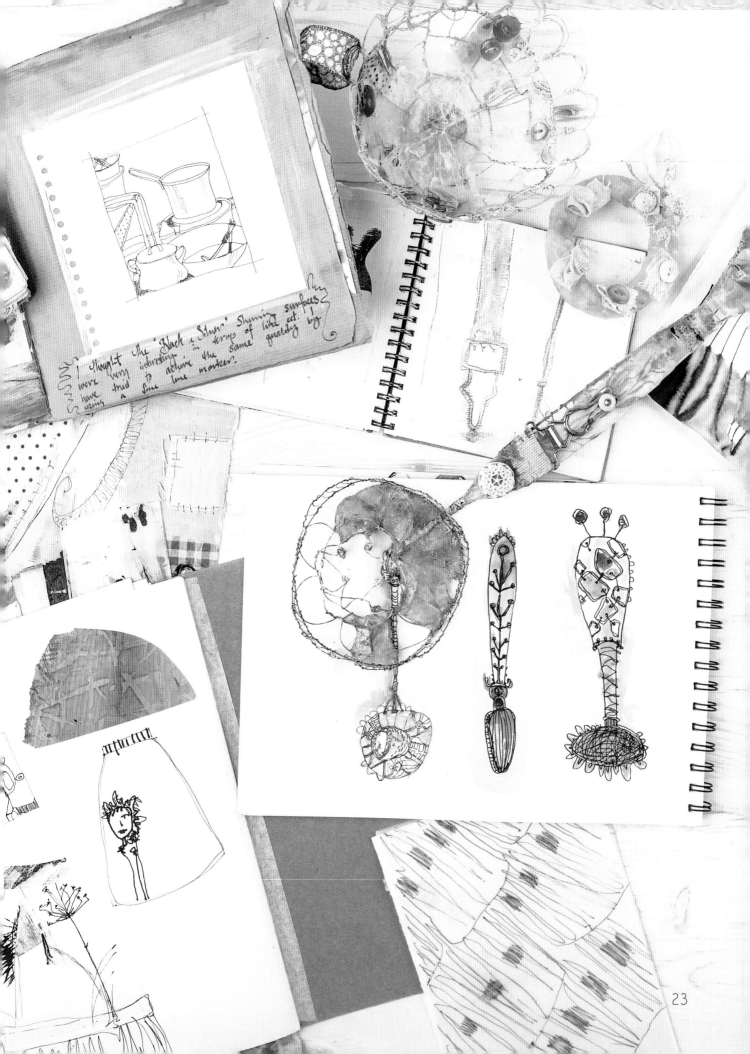

I thought the 'Black & Silver' shining surfaces were very interesting in terms of line etc. I have tried to achieve the same quality by using a fine line marker.

Bringing your ideas to life

Having selected your fabrics and with a basic plan in place for your sculpture, it is time to turn to your sketchbook. This is a place in which you can work intuitively to consider shapes, line qualities and colour before you sit and begin to work through the three stages core to all the projects: making a wire structure, adding the fabric and wax, then finally embellishing the piece.

This initial plan will help you to identify potential problems and explore different ideas as they occur to you, but don't regard what you put in your plan as the be-all and end-all. Listen to what a piece says to you as you work, and reflect at each stage. Three-dimensional textile sculpture is flexible and adaptable. Make the most of this and allow yourself the freedom to explore and respond as you work.

Plan, but keep an open mind

I tend to plan out larger pieces, like the spoon opposite, more carefully than small ones. A length of aluminum wire I had found in my stash of materials was part of the inspiration for this piece – it had a lovely dense quality that lent itself perfectly to the purpose of a handle. I used my sketchbook to get my ideas down on paper; you'll note that I initially planned to decorate the spoon with lime green and burnt orange silk.

Loosely following the drawing in my sketchbook, I explored manipulating shapes using my sketch as a guide. I added some paper-covered wire and fine iron wire to work into the structure and develop the lines I had explored in my drawing. At this point I added a small fragment of knitted wire that I had initially intended to use on a different piece – this was quite serendipitous, and at that moment the focus of the spoon changed course.

Adding the knitted wire made me rethink my original plan. The structure of the spoon had become too interesting to cover with layers of fabric. I decided instead to keep this piece nude, exposing the beauty of its construction.

Rather than adding colour through fabric, I decided to use paint instead and finished the piece by embellishing it with mother-of-pearl buttons. The embellishment could equally well have been made with stitching, or with the addition of other materials such as beads, broken jewellery and found objects.

While making your own pieces, be open to changing direction mid-course, letting the materials lead you is crucial to the development of work. Keep reflecting as you make and respond accordingly.

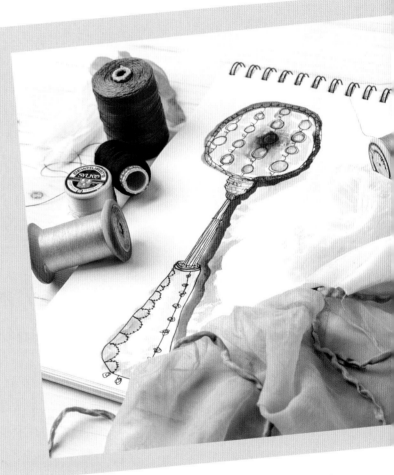

The plan
Pictured here is an example of the initial sketch from which I work, surrounded by some of the fabrics and threads that I considered while planning. If you compare the plan above to the finished piece on the facing page, the difference in colour is the first thing to strike you. Keep your eyes open as you work: don't be slavish to your plan.

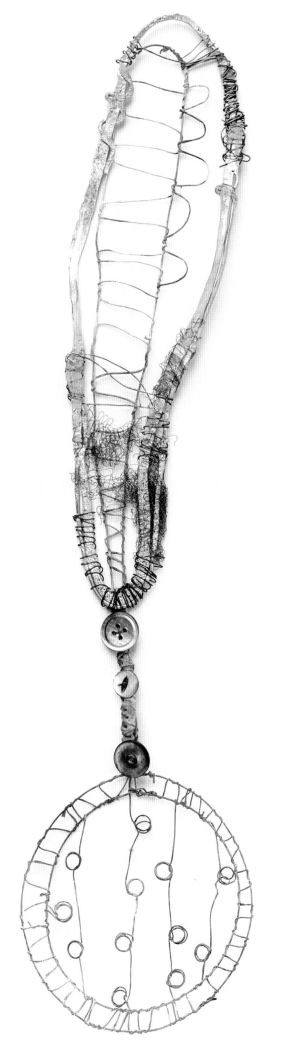

The finished piece

Part of my Loving Spoon collection, which consists of relatively large pieces. This one measures 11 x 46cm (4½ x 18in).

I enjoy the unpredictability of working with found objects and materials. They can steer a piece of work in a completely new direction. I see this as an enormous advantage to my making as it pushes and pulls me in different ways.

Souvenir Spoons

All objects have a story to share, and my assortment of spoons is inspired by the idea of collections that are unified in use but totally unique in design.

 The starting point for this broader project was my fond memories of visiting my Great Aunt Alice when I was a child. She had a large collection of souvenir spoons that she had gathered on her travels (you can read more about her collection on page 83). I loved each spoon – every one had its own individual character. I explored this idea in my sketchbook, playing with the shapes and different qualities of each spoon (in fact, you can see a detail of this precise sketchbook on page 23) before I made the collection, which includes twelve spoons in total. Here are three examples to give a taste of how varied such a collection can be – and how the same point of inspiration can lead to lots of different outcomes.

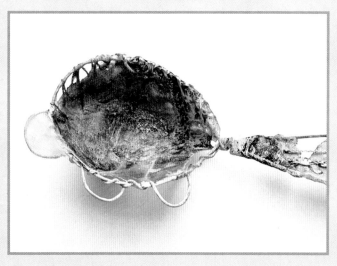

I focused on filling in the bowl of this spoon with fabric; waxing the surface and adding a looped wire edging around one side. To add contrast in terms of texture, I added whip stitches in different colours to the opposite edge. I then painted the fabric to give a sense of depth and also to highlight the texture.

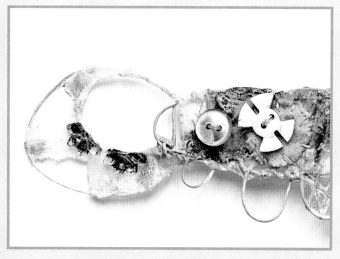

The tip on the handle of a spoon is a perfect place for decoration. Here I concentrated on adding lots of small pieces of patterned fabrics and waxed them together in layers to build up a surface. I embellished this with a piece of glove leather and a couple of 1950s vintage buttons, then added a looped edging along one side and some lace around the very tip of the spoon handle.

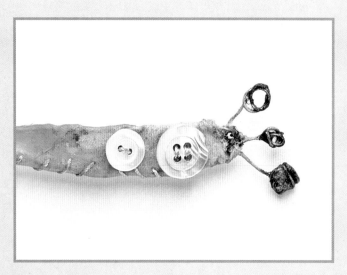

I created a small group of twisted wire balls on the handle of this spoon using the tip of my pliers, and added gorgeous gold bronzing powder to give them a slight lustre. I added whip stitch around the edge of the handle, and then, to complete the embellishment, two vintage mother-of-pearl buttons.

Opposite:

Souvenir Spoons

Top to bottom: 3.5 x 23cm, 4.5 x 20cm and 3 x 16cm
(1½ x 9in, 1¾ x 8in and 1¼ x 6¼in)

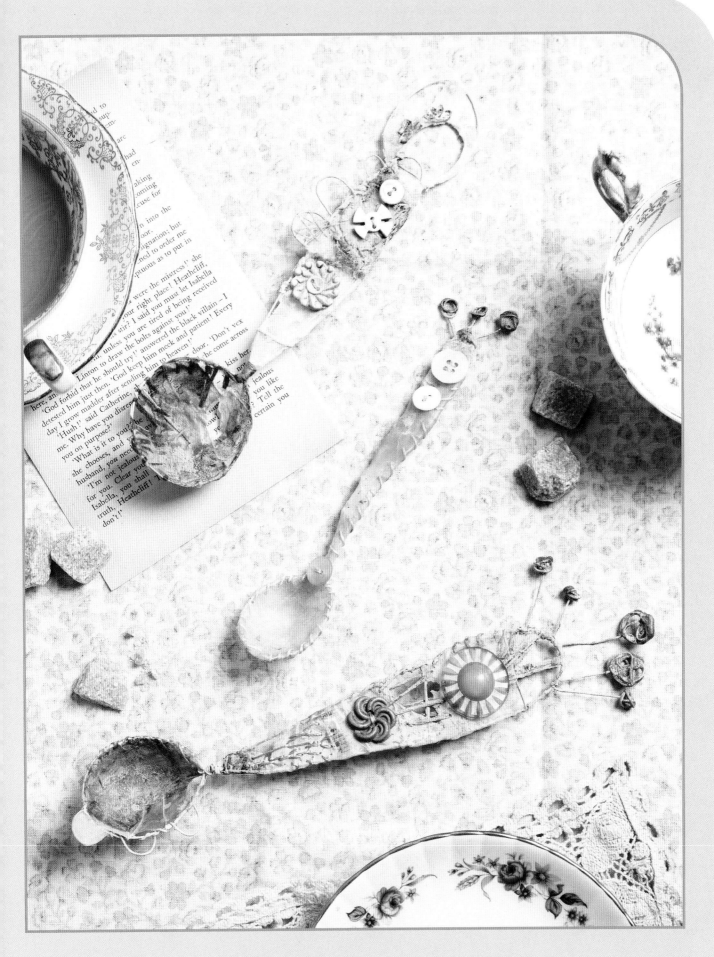

Charlotte

Found objects often feature in my work and I frequently make work specifically to incorporate a particular piece – a doll's head, for example, or a fragment of rusty metal or faded brooch that I picked up at a flea market. These pieces are a critical foundational part of the work, and they are woven, trapped and stitched into every piece to add to their individual stories.

When I find an interesting item or object, an idea will sometimes hit me like a bolt from the blue. Others take more time. Sometimes a found object can sit in my studio for months or even years until I can use it in a piece of work.

The inspiration for *Charlotte* came when I bought a tiny bisque doll at a vintage fair a few years ago. She was in a small box with about twenty other identical dolls; the label on the box called them 'Frozen Charlottes'. After a bit of research I found that they are also sometimes called 'pillar dolls', and were a popular toy from around 1850. They originated in the USA, and were based on a poem called *A Corpse Going to a Ball*, which later became a folk ballad called *Fair Charlotte or Young Charlotte*. I found the story fascinating, and so started to make a collection of small figures using found doll heads. Using the original poem as inspiration, I wanted my figure to explore the little girl transitioning from child to angel.

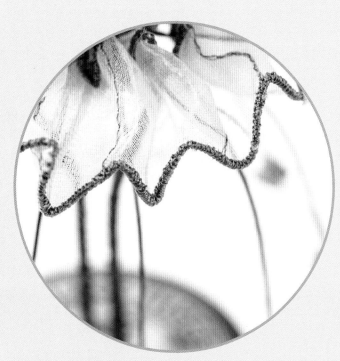

I gave my frozen Charlotte a silk ruffle collar using a machined satin stitch around the edging, over a length of 26-gauge paper-covered wire. This enabled me to shape it into a pleat before attaching to the neck. Her body is made from a simple wire structure using 24-gauge paper-covered wire and she is held in a cotton reel base using a vintage hairpin.

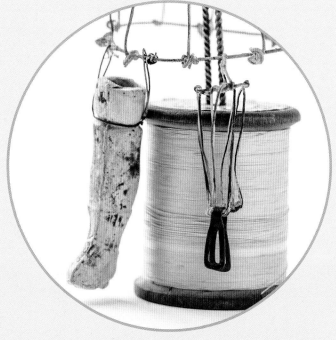

One of her legs is made from another found doll's legs, while the other is a wire structure painted with inks. A link from a vintage mirror chain was used instead of a foot.

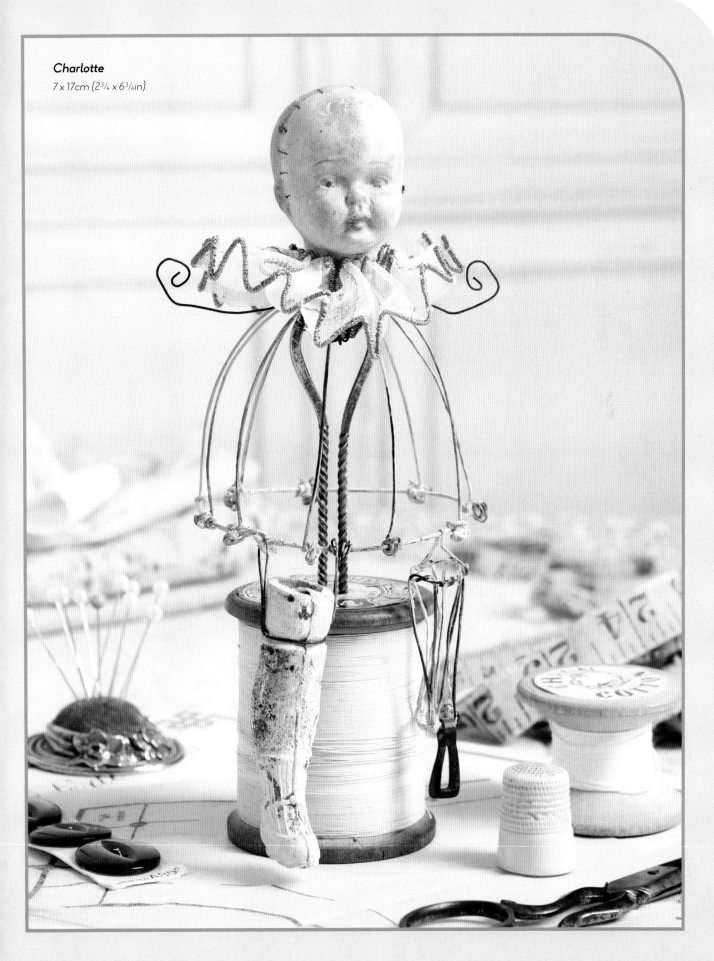

Charlotte
7 x 17cm (2³⁄₄ x 6³⁄₄in)

Techniques

This part of the book looks at getting familiar with working in wire and seeing what the possibilities are. All the basic methods of joining and manipulating the wire are explained here, so spend a little time getting familiar with them – exploring and playing with these important core techniques will help you later on.

Bending and joining wires

I suggest you start with 24-gauge paper-covered wire for structural work. The key here is to make sure that you hold the wire very firmly and securely; that's what creates good, firm joints.

Two-dimensional leaf shape

Creating a leaf is a great place to start, as it will teach you how to bend wires accurately, join wires together, and where – and what – to trim off.

1 Using a precut 36cm (14in) wire (or cut a piece to roughly this length), bend it carefully with your fingers into a soft curve.

2 Continue bending to overlap the wire.

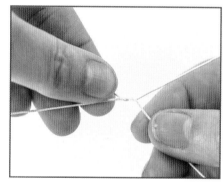

3 Pinch the wire either side of where it overlaps, and twist it round twice to join it.

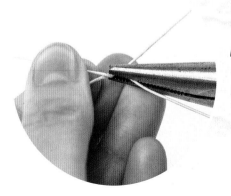

TIP

If the twisted join is a bit loose or open, it will not hold. Use your grip pliers to gently pinch the join to help secure it.

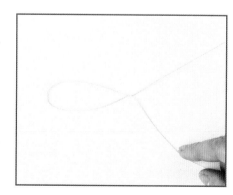

The basic outline.

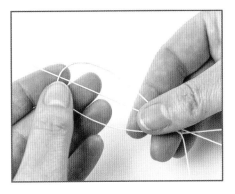

4 Take another length of wire, and thread it through the loop, with approximately 1cm (½in) past the top end.

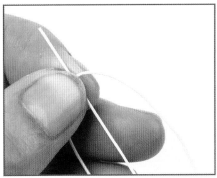

5 Pinch the join firmly.

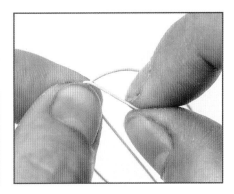

6 Keeping the joint firmly pinched, bend the overlapping wire over.

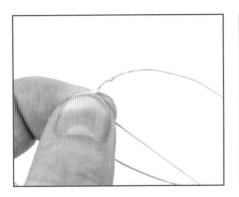

7 Wrap the wire round firmly to join the wires together. You can pinch the twist with the grip pliers if you want to make it extra secure.

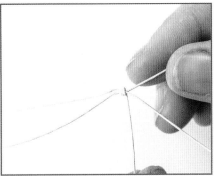

8 Wrap the other end three times around the join made in step 3.

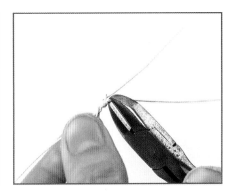

9 Use your wire cutters to trim the excess length from the first wire, but leave the second wire as is – this length can be used to join the piece to others.

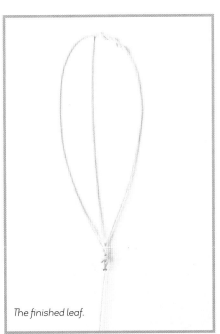

The finished leaf.

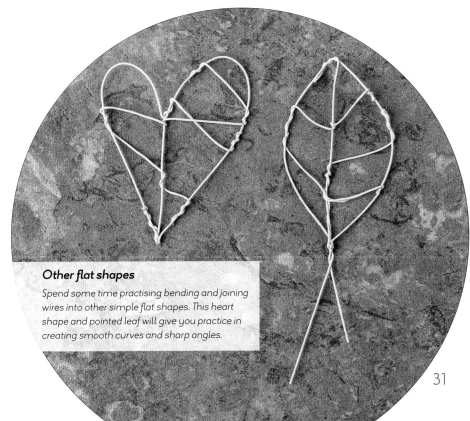

Other flat shapes

Spend some time practising bending and joining wires into other simple flat shapes. This heart shape and pointed leaf will give you practice in creating smooth curves and sharp angles.

Lengthening wires

When you need a longer piece of wire, you can either trim the correct length from a coil of wire, or join lengths together as shown here.

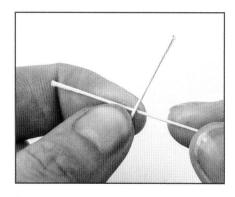

1 Take two pieces of wire of the same gauge and overlap them at right angles, with roughly 2cm (¾in) of excess.

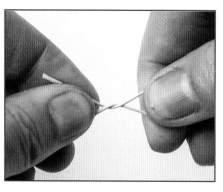

2 Twist the two to join them firmly.

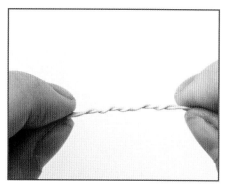

3 Wrap the excess of each wire around the other.

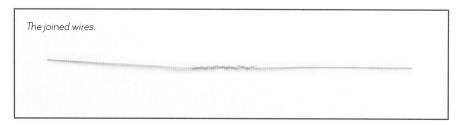

The joined wires.

Strengthening wire

Instead of using a heavier gauge wire, you can bind two lighter pieces together before using them as a single piece.

1 Overlap two lengths of wire at a shallower angle than if joining (see above).

2 Twist to join them.

3 Working slowly down the length, continue making twists every 5mm (¼in) or so. This ensures you get a firm, even twist.

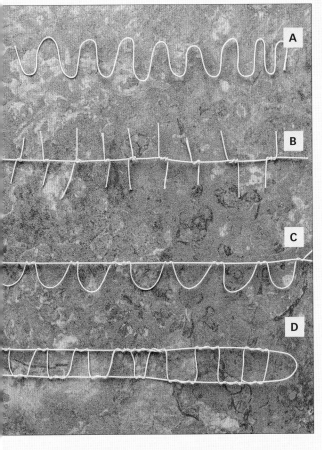

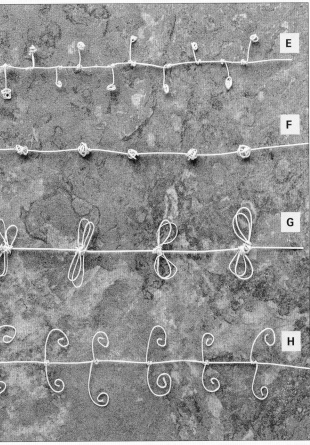

Different line qualities

With the basics of bending, joining, lengthening and strengthening wires under your belt, spend some time practising different line qualities like these:

A – Wavy line Use your fingertips to bend the wire into an evenly-spaced wave.

B – Feather line Twist shorter lengths of wire around a core wire, leaving small gaps in-between.

C – Loopy line Join one end of a length of wire to a shorter length. Wrap the longer length over your fingertip to create a loop and rejoin the longer length to the core wire using a couple of twists. Repeat all the way along the shorter piece of wire.

D – Joining two lines Create a circle by using a couple of twists to secure two ends of a length of wire. Next, pull the circle into a flat length, curving each end around your fingers. Attach a new length of wire near to one of the curved ends. Take the wire from one side of the shape to the opposite side, join it with a couple of twists, then bring it back over to the side you started on. Repeat all along the length, joining new wires as necessary.

E – Feather line with rounded ends Join a half-length of wire to the core wire. Using the tip of your pliers, twist the free end of the half-length wire around at the tip until you create a small rounded ball. Trim away any excess and repeat with more half-lengths at equal distances along the length of your core wire.

F – Twisted ball line Join a half-length of wire to the core wire. Using the tip of your pliers, twist the free end of the half-length wire around the tip until you create a small rounded ball in the middle of your core wire. Repeat with more half-lengths at equal distances along the length of your core wire.

G – Bowtie line Join a length of wire near the end of the core wire and make a loop. Bring the wire back to the middle of the core wire and join, then repeat this twice on each side of the core wire, making four loops in total. Trim away any excess wire and repeat with more half-lengths at equal distances along the length of the core wire.

H – Spiral line Attach half-lengths of wire at equal distances along the core wire, leaving equal amounts on either side. Take the tip of one of the shorter lengths and bend It into a spiral towards the core wire, then trim off any excess. Repeat with more half-lengths on the opposite side then continue at equal distances along the length of the core wire.

Creating three-dimensional shapes

When creating three-dimensional shapes, you need to make the framework or supporting structure dense enough to support the weight of the piece; and also to help support the fabric. If you leave over-large gaps in the structure, you'll struggle to attach the fabric. Aim for gaps no larger than 2cm (¾in).

Cylinder

Creating a cylinder is a good place to start making a structure: most of the larger forms in this book start with a circular shape and have either straight or curved sides. Practise making this shape and it will help you to understand how to create a basic three-dimensional form. This skill is fundamental to making more complex structures.

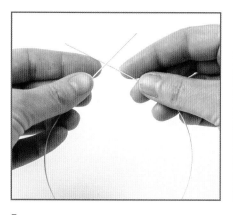

1 Bend a length of 24-gauge wire into a circle and join.

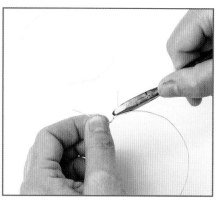

2 Make a second in the same way, and trim the ends with wire cutters.

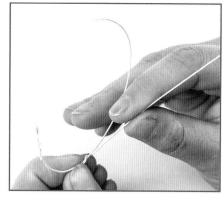

3 Join a new length of 24-gauge wire to one of the circles.

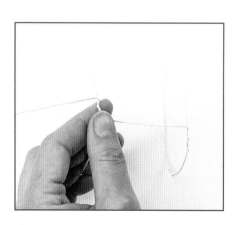

4 Join the second circle to the wire a short distance – 5cm (2in) or so – along the length.

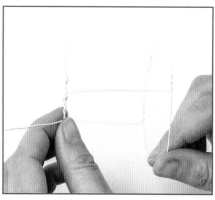

5 Trim the ends and attach another length of wire to the other side, in the same way.

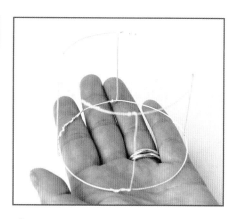

6 Repeat the process to add a third and fourth support.

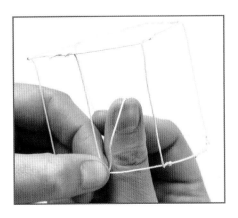

7 Join a new length of wire to the top circle, in between two of the supports. Take the whole length of wire and twist it round the bottom circle.

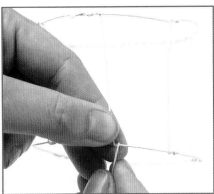

8 Pull the wire through the gap and twist it back round the bottom circle to join it.

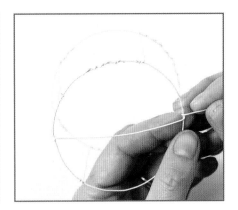

9 Take it across the width of the circle and join at the other side in the same way.

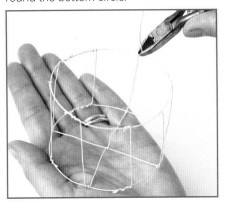

10 Join another wire in the same way to make a cross support, and trim the ends.

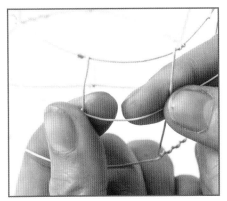

11 Join a new length of finer wire (I'm using 26 gauge) to one of the supporting 'legs' and wrap it around the centre. Changing to a finer wire makes working within three-dimensional structures easier on the fingers.

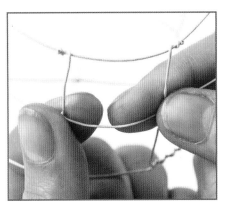

12 Secure it around the whole structure, by wrapping it at every supporting leg in turn. Gently encourage the wire to curve by pressing outwards with your fingers; this helps to ensure you get an even circle.

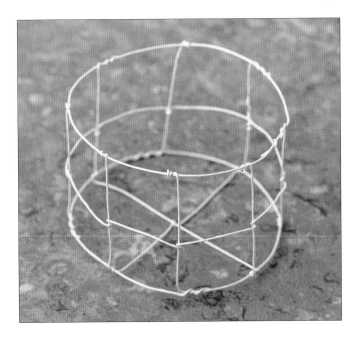

The finished cylinder

The cylinder shape could be used for a teacup, sugar bowl or the basis for a cream jug. By practising and creating this shape, you will build a better understanding of how to join wire together, shape wire and make a structure that will easily stand on its own!

Applying fabric to a wire surface

Put down a mat, newspaper or old cloth to protect your work surface, and put a small amount of wax into your batik pot before you begin. Prepare or gather lots of small scraps of fabric – small scraps lead to an attractive patchwork effect, and are also easier to handle. The size of brush you use is important. I recommend using a 12mm (½in) brush; which provides a good balance between carrying enough wax to secure a piece, but not so much that it drips and overflows.

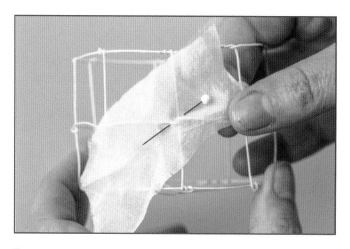

1 Pin a scrap of fabric to the outside of your wire structure (here I'm using the cylinder created on pages 34–35).

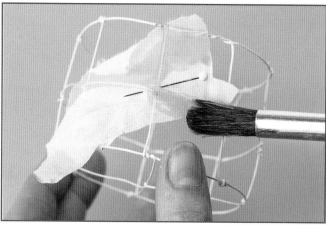

2 Very gently brush hot wax on the fabric. Always try and follow the wires to start off with; this helps to support the fabric and bond the wire and fabric together.

TIP

I'm using pins here to secure the fabric; this allows you to move your fingers safely away. Once you get more confident, you can simpy drape the fabric over the area – just be careful not to scald yourself with hot wax.

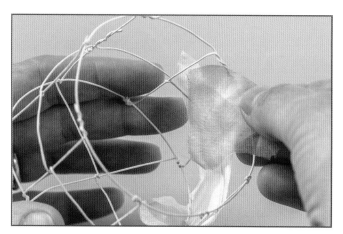

3 Place a piece of fabric on the inside of the object, backing the first piece of fabric.

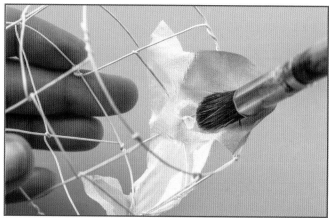

4 Use wax to secure the fabric, sandwiching the wire structure between the fabrics.

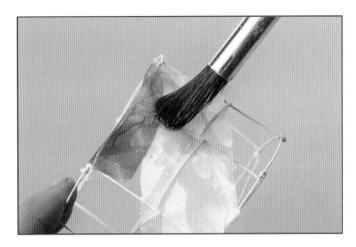

5 If any fabric overlaps the edge, use the brush to wrap it back round onto the opposite side, further binding the wire.

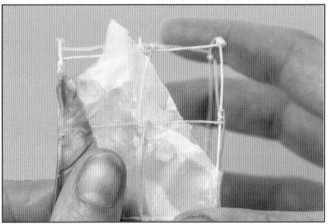

6 Allow the wax to cool slightly – for just a second or two – then use your fingers to manipulate the fabric into the shape you want.

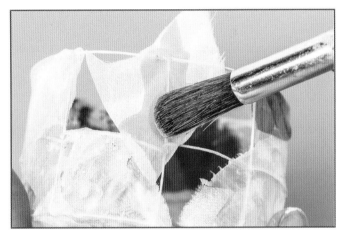

7 Continue building up the fabric layer over the piece. I like to leave lots of gaps. This is really down to personal choice and aesthetics, but I find it helps to draw attention to the underlying wire structure.

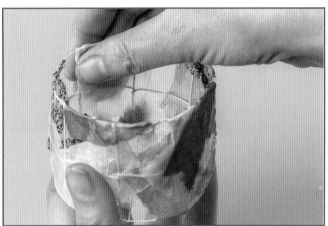

8 While the wax is still slightly warm, use your fingers to reinforce the shape of your object – here I'm emphasizing the curve by pressing gently from the inside.

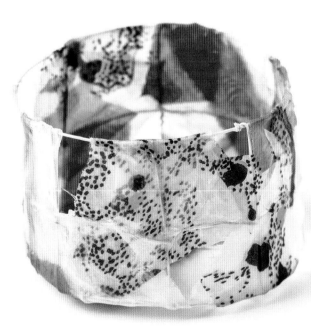

9 Continue building up so there are between two and three layers on all the covered areas. Beyond that, the fabric can become a little heavy and the piece will lose some of its translucency.

Dip-dyeing fabrics

I tend to dye fabrics in large batches and then work through them over the course of a few years; but since you don't need huge amounts of fabric for this craft, you can dye in small batches.

 To get the perfect shade of dye, do two or three colour tests with some spare scraps of fabrics before dyeing a larger piece. This can be done by timing how long your test pieces are in the dye bath. Keep a note of your results for future reference.

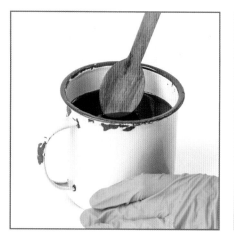

1 Prepare your dye according to the packet instructions.

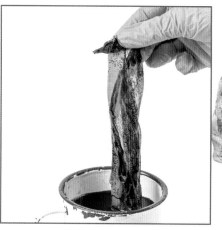

2 Dip your fabric into the dye. Note that you can use plain or patterned materials.

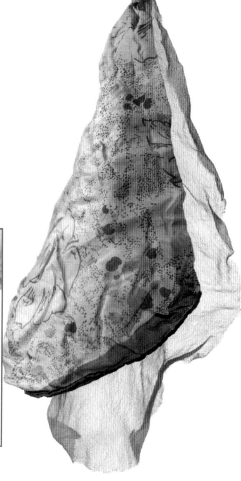

3 Leave it for a few minutes, then lift it out, unfurl it, and leave it to dry.

Colouring threads

Wrap your thread repeatedly around a piece of cardboard, then use a brush to paint stripes of ink across the wrap before leaving it to dry.

 This technique allows you to select any thread type and directly add a colour of your choice; it also allows you to add more than one colour if you wish, producing a lovely length of multi-coloured hand sewing thread to create variegated stitches.

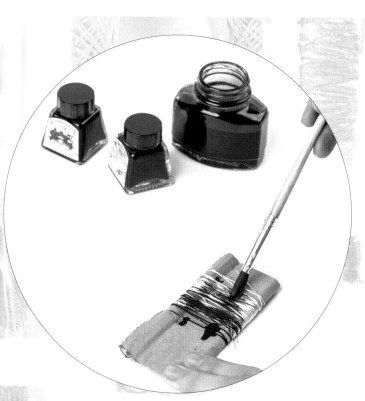

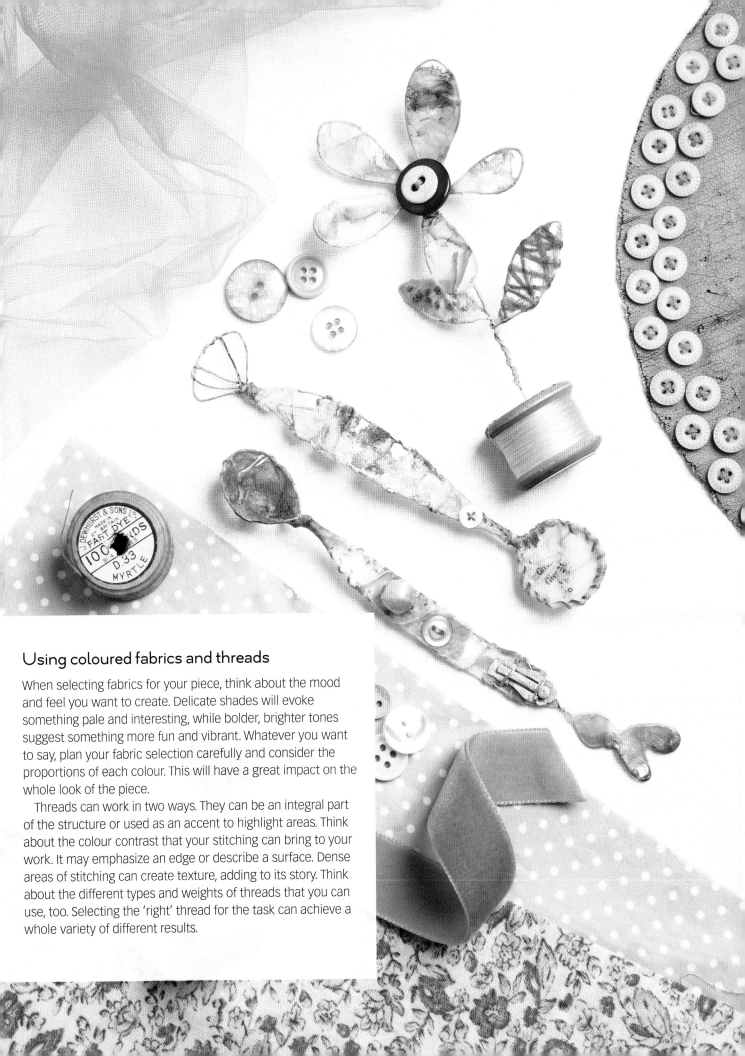

Using coloured fabrics and threads

When selecting fabrics for your piece, think about the mood and feel you want to create. Delicate shades will evoke something pale and interesting, while bolder, brighter tones suggest something more fun and vibrant. Whatever you want to say, plan your fabric selection carefully and consider the proportions of each colour. This will have a great impact on the whole look of the piece.

Threads can work in two ways. They can be an integral part of the structure or used as an accent to highlight areas. Think about the colour contrast that your stitching can bring to your work. It may emphasize an edge or describe a surface. Dense areas of stitching can create texture, adding to its story. Think about the different types and weights of threads that you can use, too. Selecting the 'right' thread for the task can achieve a whole variety of different results.

Embellishing

Embellishment adds the finishing touches that can bring a piece to life. All your searching for ephemera and haberdashery in flea markets and charity shops will now pay dividends. There are no limits to the fascinating process of embellishing – you can let your imagination take your ideas in any direction.

There are different ways to fuse your finds to a shape. I find stitching is the best way to attach a found object to wire, as it will make it really secure. However using a hot glue gun or super glue can make a great alternative where stitching is not possible.

Hand stitching is great to highlight an area on a piece; it can bring extra colour to the work, add interest to a surface, or strengthen definition on a particular part. You may wish to use stitch to describe an edge or outline an area of a patterned fabric; perhaps emphasizing a fragment of lace, or a gap in the waxed fabric.

You can use any hand stitch technique, so let your imagination move with the spirit of the piece. The journey is organic and so you should embrace the ebb and flow of the embellishing process.

TIP

Stitching or gluing large or heavy embellishments to a structure can tip the weight of the piece and make it wobbly. If this happens, consider adding something to the opposite side of a piece as a counterweight for the structure.

Examples of embellishments

A – Found object: porcelain flower I made the tip of this spoon wide enough to incorporate the porcelain flower, attaching it with super glue to make sure it was secure.

B – Found object: metal embellishment This fragment of rusty filigree metal came from an old solar light I had in my garden. I cut the piece from a larger section with wire cutters and hand stitched it to a waxed wire and silk wing.

C – Vintage buttons This teapot lid needed something bold, so I used two large vintage mother-of-pearl buttons as an embellishment to create a focal point.

D – Shaped wire I twisted small balls of wire with the tip of my grip pliers and attached them to the handle of this teaspoon. I also gave the balls a little lustre by adding some gold bronzing powder to make them sparkle.

E – Rayon thread stitching This embellishment was made using a twisted rayon thread and bridging whip stitch extending from the edge of the waxed fabric over the rim of the cup. The stitching adds some much needed texture and colour to fill the empty space. I also added a twisted ball of painted wire to give the edging some irregularity.

F – Vintage buttons I emphasized this seam on a section of leather with a row of vintage mother-of-pearl buttons bringing a focus to the lines of machine stitching and puncture holes on the right side of the material.

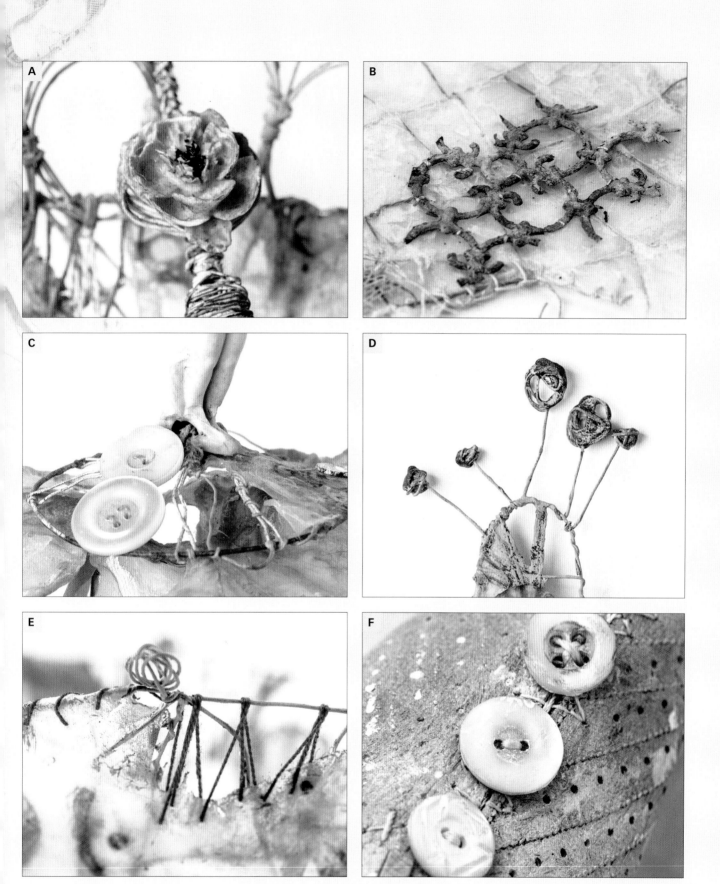

Angel of Tea

This piece is full of embellishments. It started life as a vintage hat I bought from a charity shop for the princely sum of one pound! After removing the brim, I used the crown to create a chic crinoline skirt for the base of the angel. The flowers around her waist are from an old wedding bouquet that had been made up from lots of silk organza. The angel's wings are fragments of antique lace that I stitched into with free machine embroidery (see pages 56–59) before attaching to the porcelain doll's head.

It was important to keep this piece really delicate, so I opted to use a very pale colour as a background for the wire spoons that decorate the skirt. All the spoons were painted with dusty pink acrylic and embellished with a little gold bronzing powder to add a touch of elegance. Finally, I used cream rayon crochet thread to add whip stitch around the edge of the crinoline. This final embellishment served two purposes: to hold the layers of the fabric in place and to add an accent of colour.

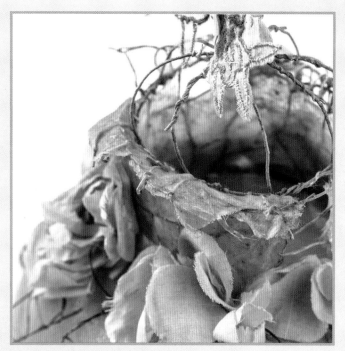

Opposite:
Angel of Tea
18.5 x 24cm (7¼ x 9½in)

The top of the piece is intricately embellished and decorated. Compare this with the relatively simpler, cleaner base. This contrast helps ensure the focus is at the top.

This detail shows the bowl of one of the spoons. Note also the whip stitch at the base.

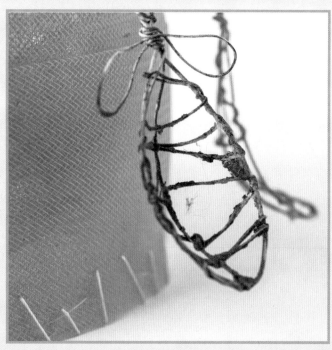

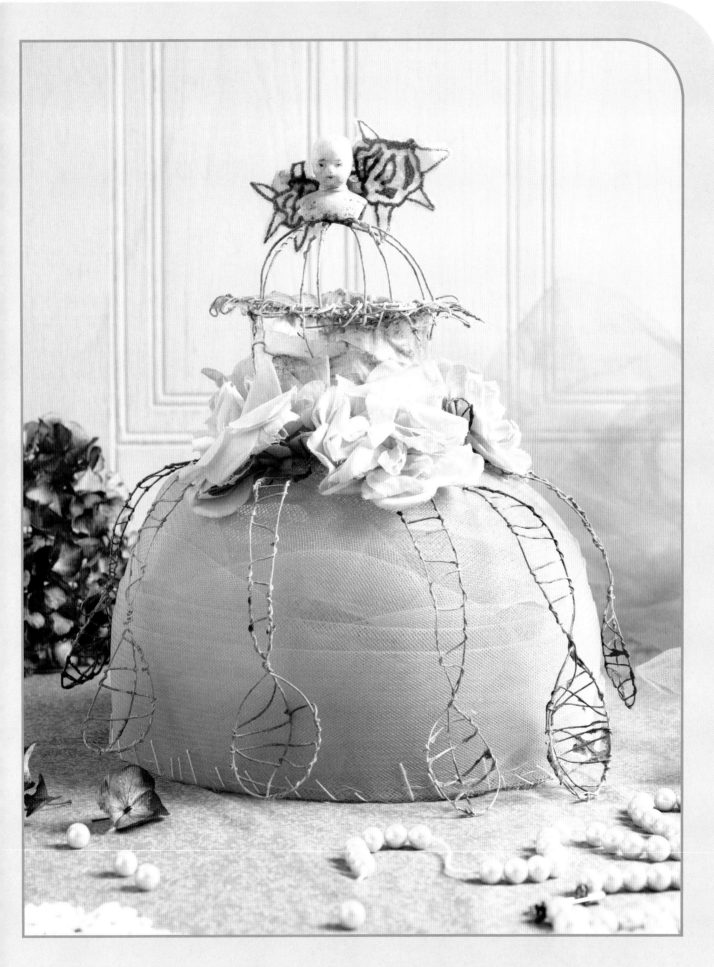

Cinderella's Memento

Cinderella's Memento has many different types of embellishment that follow the strong lines of the shoe shape. I've used many mother-of-pearl buttons to suggest a decorative edging around the top of the shoe.

The focal point for the piece is a fabulous vintage ring size measuring tool that is made from celluloid. When fanned open, the measure struck me as the perfect decoration for the front of the shoe. It was stitched in place, and then I added a 1960s earring made up of multiple plastic beads. It was a bit glitzy but I adored the shape, so I toned it back by applying a thin coat of acrylic pink paint. This piece is thus a good example of how inspiration can strike as you work, each embellishment suggesting the next.

I also used whip stitch around the edge of the shoe, using a cornflower blue rayon crochet thread and hints of machine embroidery in the form of flowers. I made this piece especially for an exhibition about shoes – sadly I didn't get to wear them!

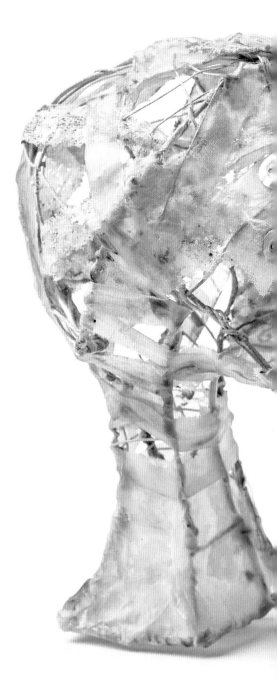

Cinderella's Memento

29 x 16cm (11¹/₂ x 6¹/₄in)

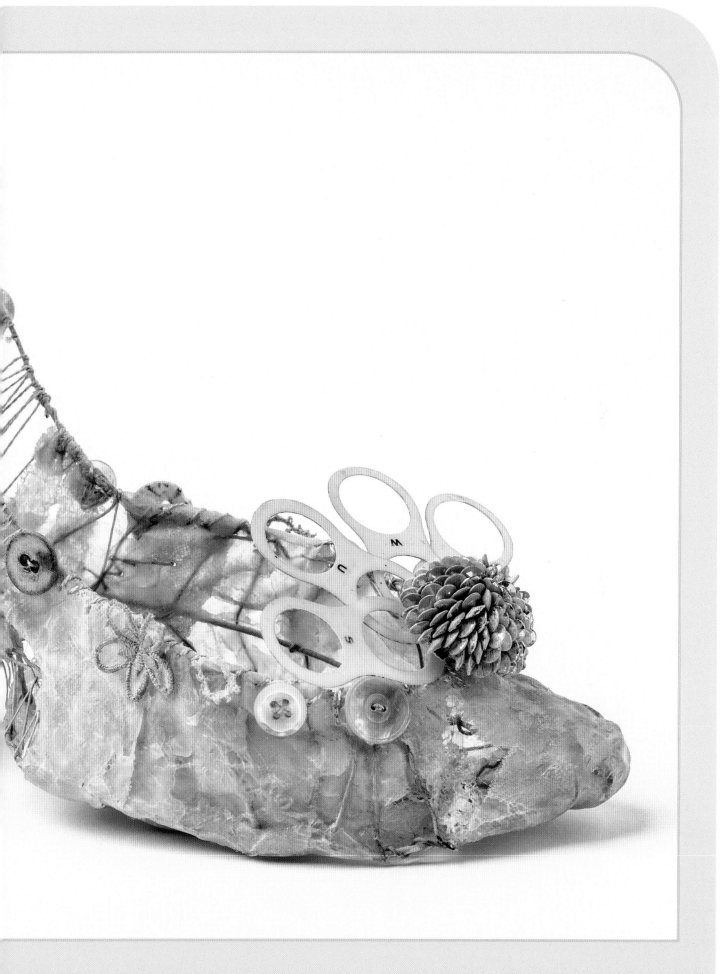

You Clipped My Wing

I wanted to use lots of hand stitching to give this little creature a sense of having been broken and mended over and over like a well-loved childhood treasure. To emphasize the hand stitching and build on the core concept, I selected an eye-catching deep red thread to contrast with the fabric and clearly define all the embroidery.

Her head has been damaged and repaired with a strong adhesive and these joins have been accentuated and emphasized with a touch of gold bronzing powder. The repair is an integral part of the piece and suggests a time when the creature was neglected but found and restored. I imply that the limbs have been lost over time and replaced by other things, including a feather and an arm-like structure fashioned from wire.

On the creature's hand, I used a small ball of silk from a vintage scarf and embellished it with a seed stitch.

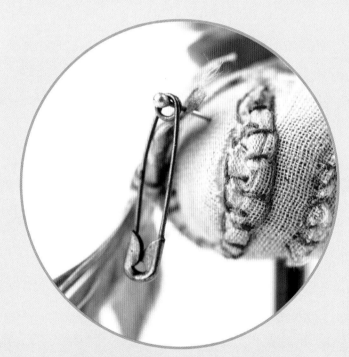

I wanted this creature to have moving limbs, so the feather and brass safety pin has simply been held in place with a dressmaking pin to provide the creature with a flexible anatomy. I wanted to use more than one method of hand stitching and opted for buttonhole and whip stitch to decorate the body. This is an example of applying visible mending.

This limb is made from iron wire and attached to a vintage earring. I tend to make some elements of a piece moveable, and the screw part of an old earring was perfect here as an adjustable shoulder. I used whip stitch to couch the part in place, making it a stronger feature.

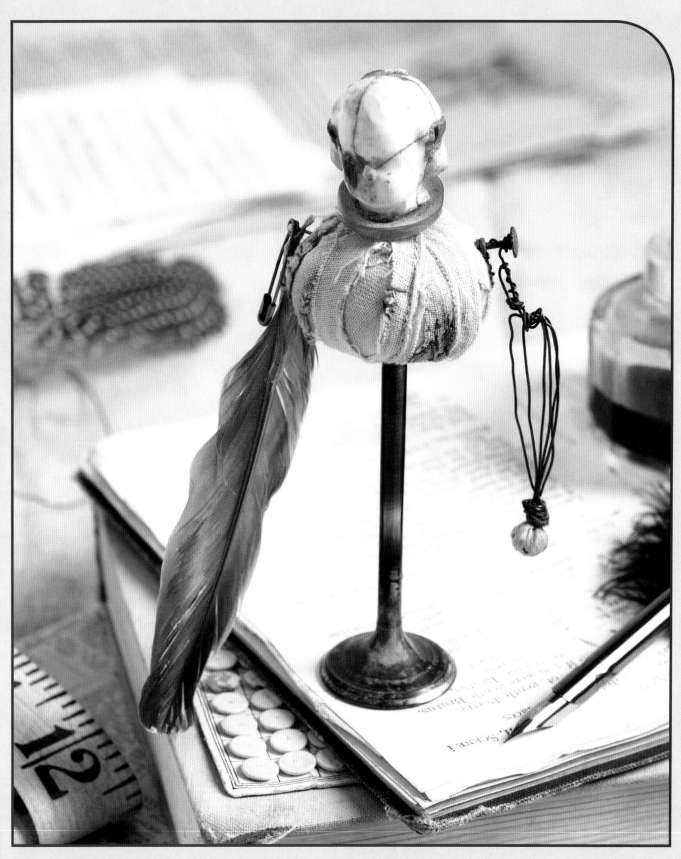

You Clipped My Wing
5 x 12cm (2 x 4¾in)

Hand stitching

Hand stitching is an exquisite way to embellish a finished piece, but it can also be used as an integral part of the structure. Therefore, there is a lot to think about when selecting the right threads and stitch techniques; you want them to harmonize and enhance the structure. A smooth solid area of waxed fabric is a good background for a cluster of stitches, and an edging can be great for highlighting with an accent stitch.

Start by choosing the stitches you would like to use and consider where you might add them to your sculptures. A selection of my favourites are shown on the following pages, along with some details of how I have used them in my work.

When planning your hand stitching, consider the following points:

Choosing the right stitch Stitching is much the same as putting a brushstroke on canvas, so consider the type of mark you want to make. A stitch can be bold or delicate, and selecting the right stitch is therefore important. Small isolated stitches with large gaps in between each will give a more delicate feeling. French knots, seed stitch or fly stitch work well to achieve this effect. A continuous stitch, such as blanket or running stitch, can provide a stronger impact. Likewise, a cluster of any stitches will stand out as a bolder statement. You can, of course, also mix different stitch types together to create an interesting surface (see page 52–53 for more on combining stitches).

Selecting the right thread for purpose There are two main categories of thread, stranded and twisted. Each one has its own unique qualities and which you choose will depend on the effect you want to achieve. A stranded embroidery thread may be separated into individual strands which you can then use singly, or as many as you wish – though around six strands is the most I would recommend. This means you can play around with the weight of the stitch, using several strands when you want a stronger mark with more impact. Stranded embroidery will give a smooth flat finish to your stitch. A twisted thread is a single thread with two fine strands twisted together. These come in a variety of different weights. Twisted threads catch the light beautifully, better than a stranded embroidery thread, so they are prefect when you want a stitch to really stand out.

Thickness of the thread The heavier the thread, the stronger the mark will be. You have to decide what is the most appropriate weight of thread before you begin. If using stranded threads, you can, of course, remove some of the strands to create finer marks, while if you want to describe a bolder stitch, increase the thread weight or even double up the thread. If you want a really bold stitch you could use ribbon or yarn.

All the threads mentioned above can be used as part of the structure, to attach buttons or found objects, or simply as decoration. There are no rules when it comes to thread choices, though you may wish to consider the quality of the thread finish and the type of effects it can create – a cotton thread will provide a smooth matt finish, for example, while a rayon/viscose thread will catch the light and give a lovely silky sheen. A silk thread comes somewhere between the two, with a forgiving softer sheen.

French knots

French knots are a favourite of mine. They are easy to make on the hardened surface of a sculpture because all the work is done on the exterior side.

French knots are very versatile; they can be clustered together to make a bold statement or used separately to create delicate dots of colour on the background material.

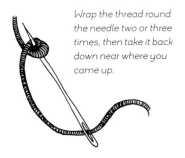

Wrap the thread round the needle two or three times, then take it back down near where you came up.

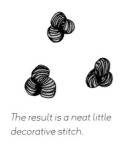

The result is a neat little decorative stitch.

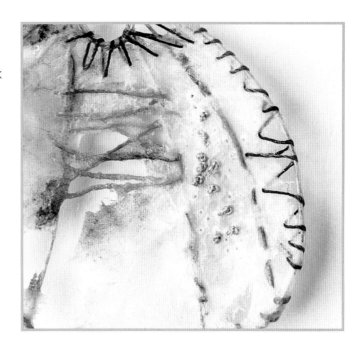

Whip stitch

Excellent for adding interest and strength to edges, whip stitch can also be used to work over areas of a sculpture that have a gap in the waxed silk. This can bring interest to an empty area of a surface, highlighting the negative space and punctuating it with colour and an alternative texture.

Vary the length of the stitches you make, and cross some over others for added interest.

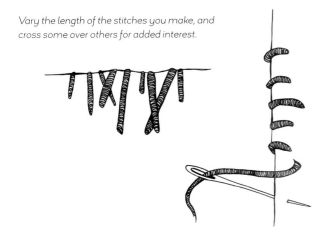

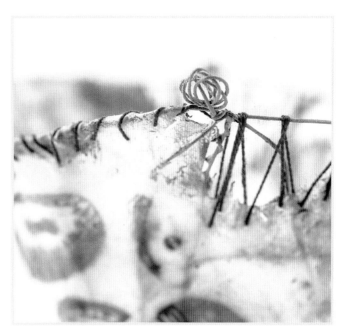

Bridging whip stitch

Using whip stitch with very large stitches to cover gaps plays a key part in my work. I refer to it as bridging whip stitch, and it is worked in exactly the same way as whip stitch; simply with each stitch varied in size as necessary to bridge the gap.

Fly stitch

Fly stitching works well as a single or continuous stitch and can be attractively grouped together in a cluster. You can vary the length of the stitch, stretching the 'V' shaped loop out and catching it in place with a short or long vertical straight stitch. The beauty of this is that it can be altered in scale to fit into a particular space. I like using these on teaspoon handles and around teacup edges.

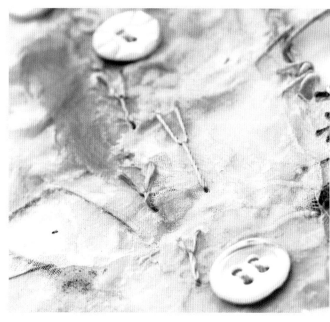

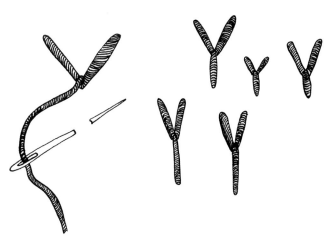

Running stitch

Running stitch provides you with a precise or variegated continuous mark. It is the simplest stitch of all to work and can add an attractive quality of line to any piece. Running stitch also looks really effective when worked together in rows moving in a vertical direction.

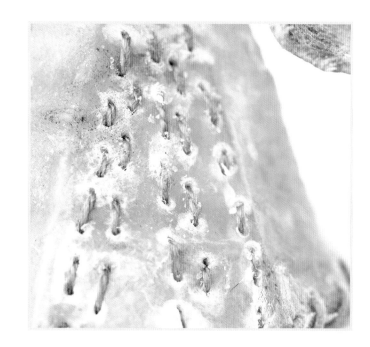

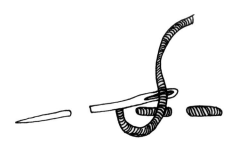

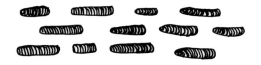

Buttonhole stitch

Buttonhole stitch is a really attractive stitch that can be worked along the edge of a piece to highlight both interior and exterior shapes at the same time.

I often choose this stitch to work over a found piece of ephemera or rusty metal as it brings a lovely sense of detail to a surface. It also works beautifully when used with variegated and thicker threads, where it provides a lot of impact.

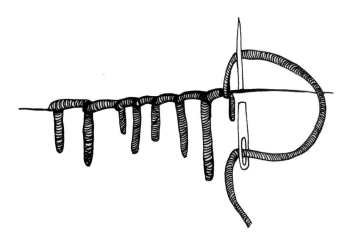

Seed stitch

You can use seed stitch in a similar way to French knots either in constellations or as an individual stitch. You can vary the length of the stitches to get different effects and scale them up by using a thicker thread. The random nature of this stitch can add a subtle touch of texture to an area or a space that simply needs an accent stitch.

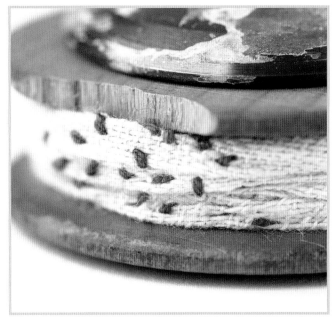

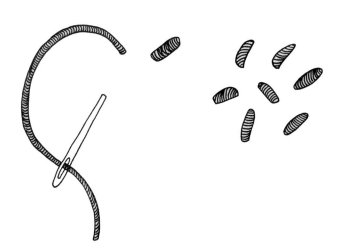

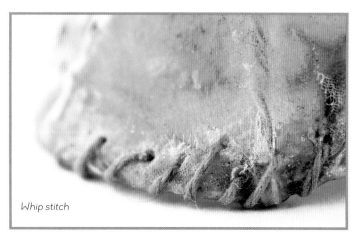

Whip stitch

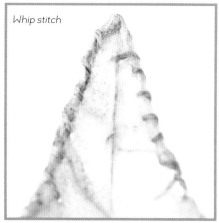

Whip stitch

Combining stitches

Stitching is a wonderful process; there is so much you can say with a stitch. It can help to describe an area of a finished shape or define certain parts, emphasizing a surface and highlighting its importance. When you add a stitch you are creating a mark in the same way that you might draw with a pencil – and so combining stitches becomes a new way of extending your drawing skills.

I usually choose no more than three different stitch techniques for a piece. Any more than this and it can over-complicate the appearance.

Experimenting with different combinations will provide you with a variety of different outcomes, so take risks and see what happens – exploring the possibilities is so much fun!

Colour is the key to creating a successful result and it can bring some much-needed contrast to a piece. Think about the shades you select and how they work with your base colour. For the little cream jug shown here, I selected a pink twisted cotton thread and a pale blue twisted vintage crochet thread. Both colours contrast well with the pale turquoise background. I used two types of stitching for this piece – a running stitch that I clustered on the base of the jug and a whip stitch that I worked around the base rim, side and handle.

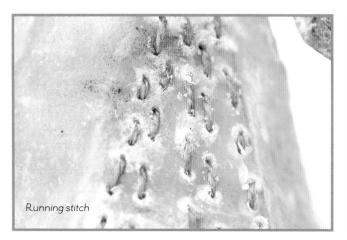

Running stitch

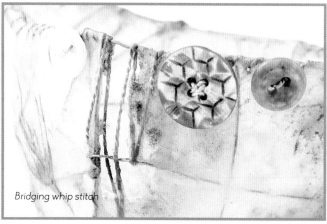

Bridging whip stitch

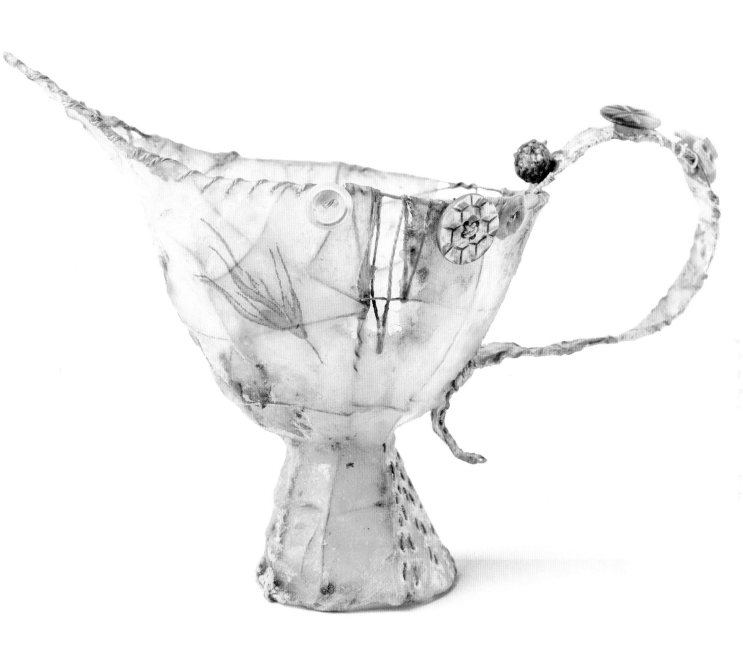

Little Blue Jug
19 x 14cm (7½ x 5½in)

Cream Jug

This delicate little cream jug, made using the fabric from a faded vintage scarf, has a lot of complex elements including buttons, folded leather and an old spring incorporated into the handle. I wanted to accentuate the areas of pattern by using a stronger thread colour to define certain areas of the piece. Not wanting to make the piece look too fussy, I opted to use one colour and type of thread and just two stitch techniques: running stitch as the main embellishment and whip stitch to draw attention to the edge of the jug.

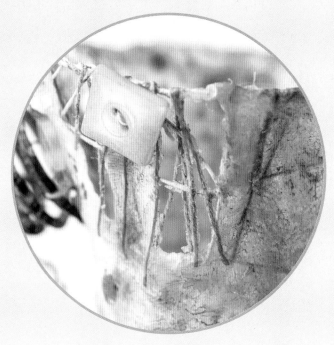

This detail shows a section of the jug's rim. The bridging whip stitches here are long and extend about 3cm (1¼in) from the edge of the jug down the side of the piece. I worked the stitching over a negative space, bringing in a much-needed splash of colour, then added a mother-of-pearl button to complete the area of embellishment.

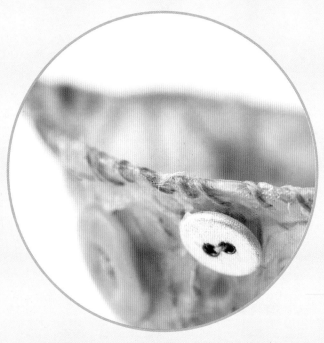

I used the same green thread as for the bridging whip stitch (see above right) to work around the edge of the jug, and highlight and finish off the rim. I also stitched more embellishments here – a vintage peach plastic button and a white linen button just below the edging. The surface qualities of these different types of buttons creates a great contrast: one is smooth and shiny, the other is matt.

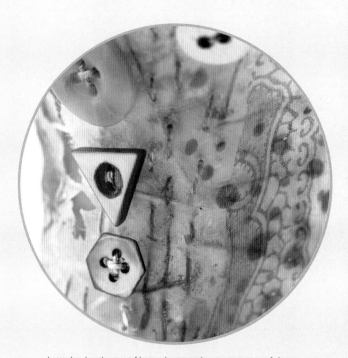

I stitched a cluster of lines that ran down a section of the jug on the plain area of fabric sitting against the patterned silk. I used a similar length of stitch to suggest a textured surface that would lead the eye towards the vintage buttons. As earlier, I opted to use buttons of different shapes and colours to add a hint of variety.

TIP

If you find that stitching is becoming a little addictive and you are hungry for more, invest in a good hand embroidery encyclopedia or spend a little time searching online for different and exciting stitch techniques – there are simply hundreds you could try!

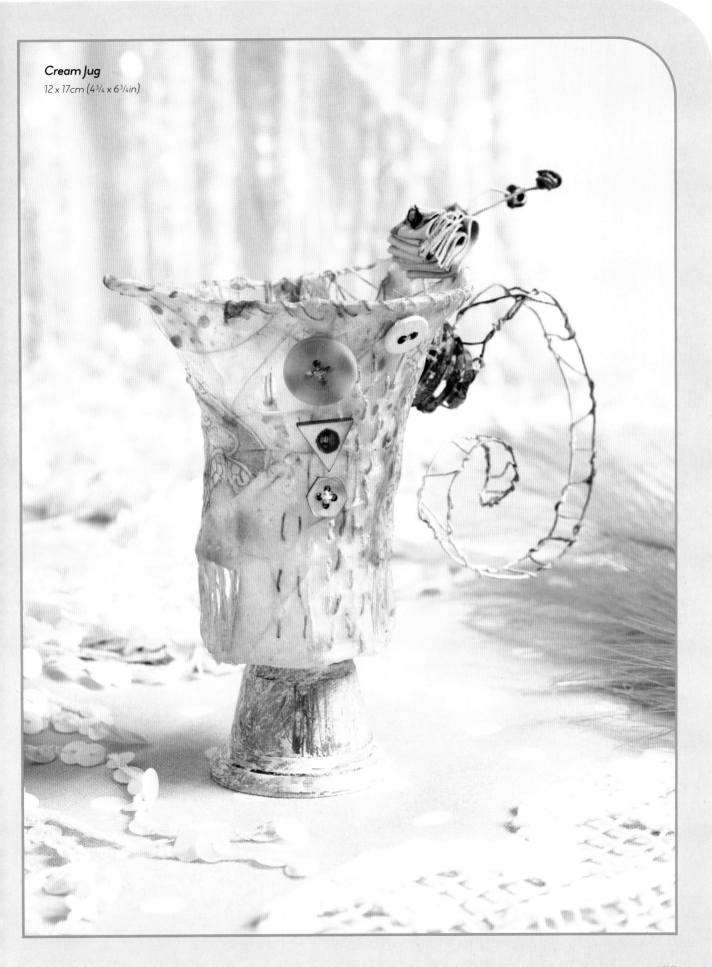

Cream Jug
12 x 17cm (4¾ x 6¾in)

Free machine embroidery – the basics

Free machine embroidery is very liberating. You can take your line of stitch in any direction, creating beautiful drawings and marks on your fabric. By experimenting with various threads and stitches, machine embroidery will allow you to invent an abundance of textures and surface qualities in your work, making it unique to you. There is an unlimited array of different thread types available, so creating contemporary embroidery has never been so exciting or full of potential.

There are two things that are key to stitching beautiful embroideries. The first is learning to understand your own machine and the second is simply practising your stitching. After that embroidery can take you anywhere you want to go!

TIP

Always bring the spool thread up onto the surface of your fabric before you start to stitch – this way you can avoid a messy tangle of threads on the underside of the fabric. It's also good practice to manually engage your needle in the fabric before you begin to stitch.

If you haven't tried this way of stitching before, then have a little practice on some spare fabric until you get more confident. It is huge fun and very addictive – you are sure to get carried away.

Setting up your machine for free machine embroidery

Each machine can vary slightly, so to set your machine up for free machine embroidery you should check your model's manual for guidance. Generally, you will need to drop the feed dogs (the little teeth that sit in the middle of the throat plate) on your sewing machine, and then remove your presser foot. Attach your free machine embroidery foot or darning foot and thread the machine with your chosen thread. Fill an empty spool with the same thread and place in the bobbin casing. Next change the needle for an embroidery needle (see page 12 for details on the best type to use). Set your stitch to 'straight stitch' and stitch length to '0' and you are ready to go.

Needles

Replace sewing machine needles regularly: needles last for around four to six hours of continuous sewing. After this point they can start to wear and burrs may appear on the needle, causing threads to break more easily. Always dispose of needles properly, in a sharps bin. It's also good practice to use a different needle every time you change your thread type. For example if you switch from using cotton thread to rayon, you should also change the needle.

Machining over wire

Be very careful when working a machine stitch over wire. It's important to set your zigzag or satin stitch wider that the width of the wire to ensure that you do not catch the wire with your needle while stitching. If you do hit the wire the needle is likely to break, and it may also push the wire down into the throat plate on the machine. If this happens, don't worry. Wiggle the wire back out until it becomes free – a pair of tweezers can be useful for this task.

Try writing your name on a scrap of paper – it's a great way to practise free machine embroidery.

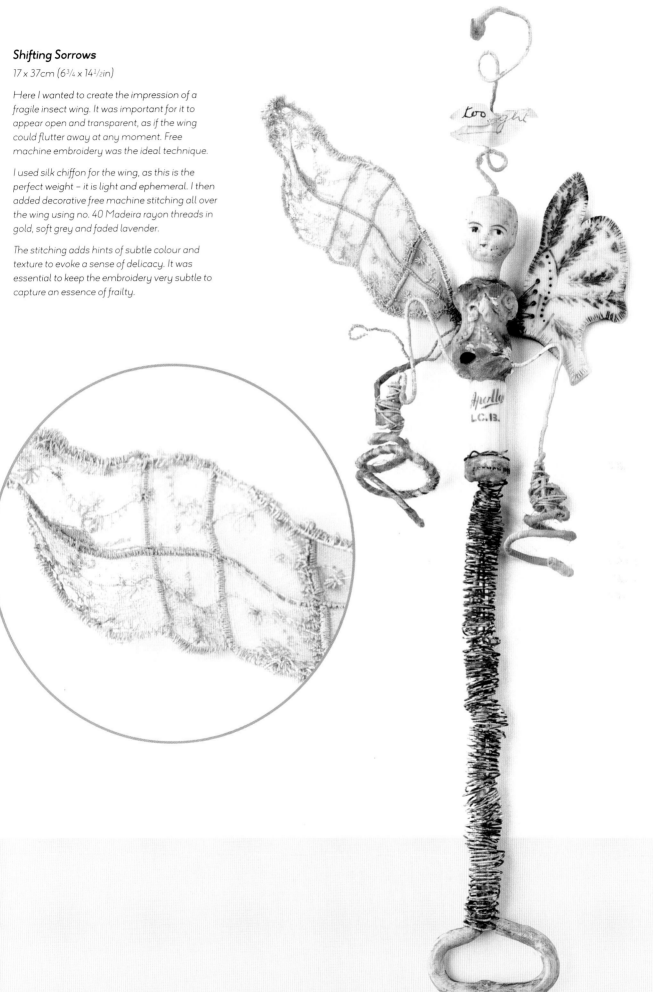

Shifting Sorrows

17 x 37cm (6³/₄ x 14¹/₂in)

Here I wanted to create the impression of a fragile insect wing. It was important for it to appear open and transparent, as if the wing could flutter away at any moment. Free machine embroidery was the ideal technique.

I used silk chiffon for the wing, as this is the perfect weight – it is light and ephemeral. I then added decorative free machine stitching all over the wing using no. 40 Madeira rayon threads in gold, soft grey and faded lavender.

The stitching adds hints of subtle colour and texture to evoke a sense of delicacy. It was essential to keep the embroidery very subtle to capture an essence of frailty.

Free machine embroidery technique

This technique works best with light wires; no thicker than a 26 gauge. Any thicker and you risk catching the needle on the wire, distorting the shape or even forcing it into the machine. This can damage the needle, as noted on page 56. It is unlikely to damage the machine itself if you stop immediately, but it is time-consuming – not to menton annoying! – to extract.

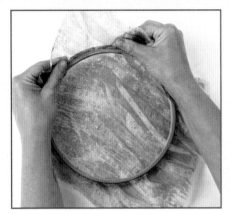

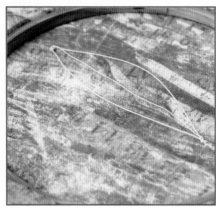

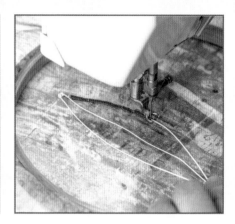

1 Use an embroidery hoop to stretch and tension the fabric. Note that the right side of the fabric should be facing the back of the hoop frame; that is, the other side to how you would use it for hand embroidery. Ensure that the fabric is drum tight.

2 Place the hoop on your surface, then take your wire shape and place it on top of the piece of fabric, within the hoop. If you're using a patterned fabric, spend a little time working out where the pattern will sit within your shape.

3 Place the hoop on the machine, and drop the darning foot onto the wire shape. Bring both threads to the top of the fabric. Using a zigzag stitch, with a minimum width of 4 (any less will catch the wire), begin to work along the outline of the shape. Concentrate on working along the wire, and work slowly so that you don't catch the wire with the needle.

4 The fun of this technique is really when you begin to work inside shapes. Change to a straight stitch and treat the needle like a drawing tool, creating your own marks to develop the story of your own piece. Here I'm stitching swirls within the right-hand part of the wire feather shape.

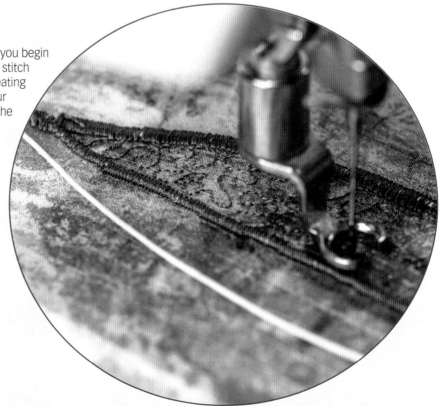

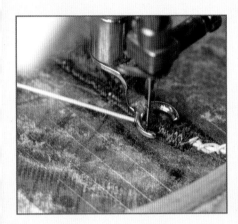

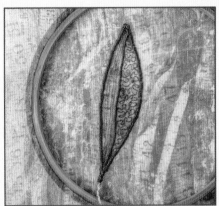

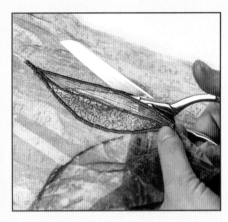

5 Fill in an area, then switch back to zigzag stitch to start on the next outline. When you reach joins, the wire will be thicker; so increase the width of the stitch.

6 Continue until you have covered the wire and filled the shapes to your taste, then trim the threads and remove the hoop from the machine.

7 Use some very sharp dressmaker's scissors (or very sharp embroidery scissors) to cut out the shape carefully. Work along the stitching, being very careful not to cut into the thread itself.

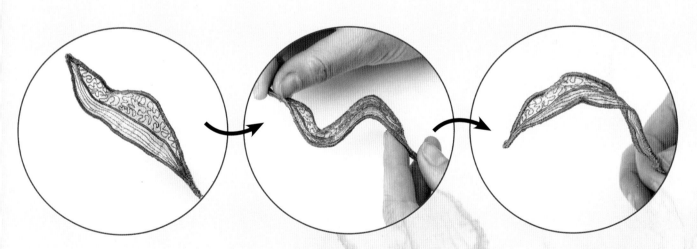

8 You can now bend the piece into shape. Depending on the fabric you're using, you may need to be a little more delicate, but generally you can be quite robust with the pieces.

Loving Spoon

This loving spoon is part of a larger collection of twelve spoons, each unique in shape and decoration; I have used different embroidery techniques on each of them. Traditional loving spoons, or *llwy gariad* in Welsh, were handmade from wood in Wales as a gift of romantic intent. My love for these intricately decorative spoons stems from my Welsh heritage; I affectionately remember my Nain's (grandma) own loving spoon kept in a special place above the fire surround in her front room.

To embellish the spoon – see opposite – I used dyed strips of silk to add buttonhole stitching along the lower part of the spoon handle. Using strips of fabric is a very effective alternative to using finer embroidery threads to embroider parts of a piece, as the bold strips of silk stand out because the scale of the stitch has been increased.

Continuing my decoration, I used a small piece of feathery blue silk to cover a button before attaching it to the upper part of the spoon handle. I stitched around the outer edge of the silk covered button using a fine rayon floss thread and dotted French knots around the border to add a hint of texture. Adding small details like these can help to make the piece more unique and distinct.

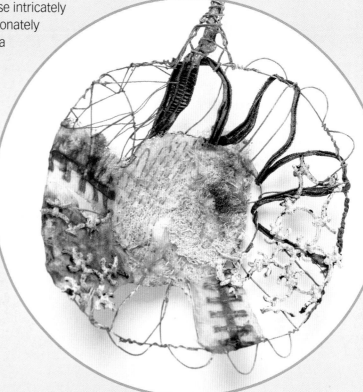

The bowl of the spoon is made up of wire and pieces of waxed silk. I have used several ways to embellish this piece including a denser vintage millinery wire, which I interlaced into part of the structure around the centre of the spoon. This created an interesting overlay of different weights of wire. I decorated the edge of the spoon bowl with loops (see technique C on page 33) and by attaching fragments of filigree metal. These were painted with cream and pale pink acrylic before being hand-stitched in place.

In the centre of the spoon I added a patch of densely-stitched free machine embroidery. I created this separately using dissolvable fabric as a base. After washing the Aquafilm away and allowing it to dry thoroughly, I hand-stitched it in place. I also added touches of watered-down ink around the edges to accentuate the texture. As a contrast to the highly textured machine stitching, I used lines of running stitch on the background fabric using a twisted rayon crochet thread.

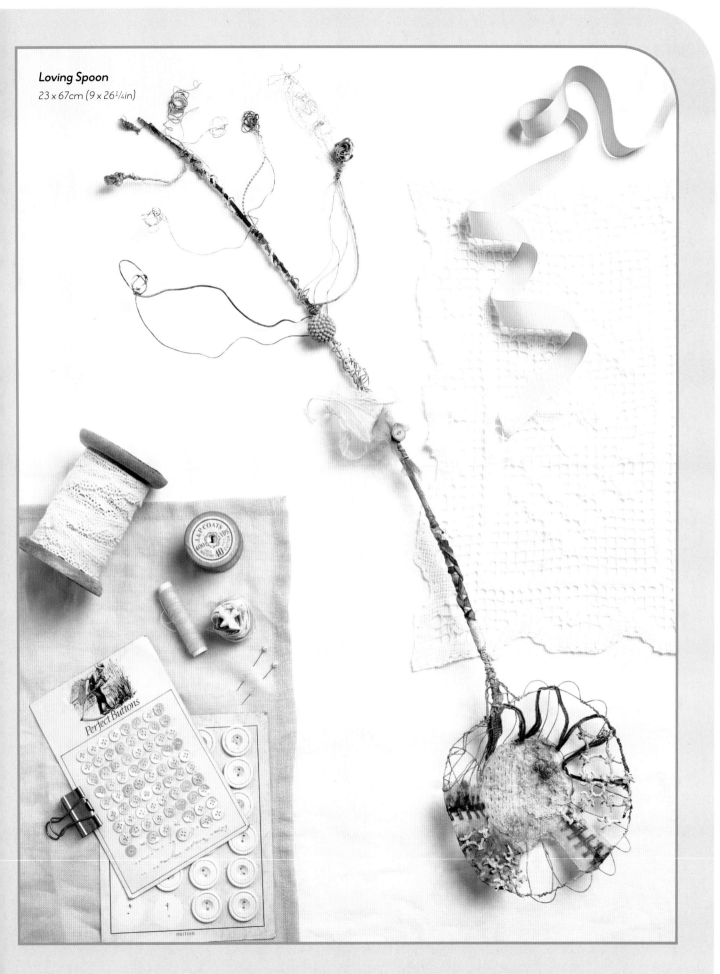

Loving Spoon
23 x 67cm (9 x 26¼in)

Curious Creatures

My fairytale creatures are almost always adorned with delicately stitched wings. I created the examples below using 26 gauge wire gently fashioned into feather shapes before being worked over with a cotton machine thread and satin stitch. Dissolvable fabric was used as a base to stitch upon, which helped to stabilize the structure.

 I wanted these wings to feel slightly stiff and highly textured. Adding paint, as I have here, is a great way to achieve this effect but you could try out other ideas such as watered-down PVA. Experiment and try your own ideas too. The finished pieces on the page opposite demonstrate how effective even subtle variations can make something totally unique.

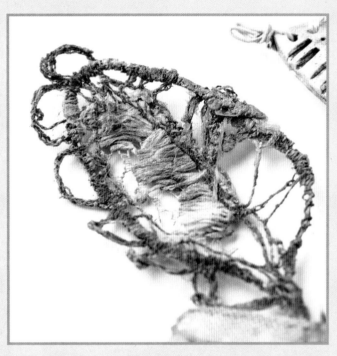

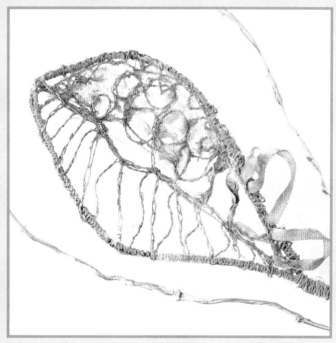

I used free machine embroidery to work lines of straight stitch across the structure to trap fragments of the lace in place. I then added a scalloped edge around the left side of the wing with two or three lines of straight stitch. Once complete, I washed away the dissolvable fabric and allowed it to dry completely. I then used watered-down white acrylic paint to tone down the intense red thread, giving it an aged appearance.

This wing was created in exactly the same way as the other – lines of straight stitch being used to create an open and delicate feel. The difference comes from the addition of a touch of pale grey silk ribbon, which I used to create small loops along the right-hand edge. I also finished it off with a wash of watered-down paint.

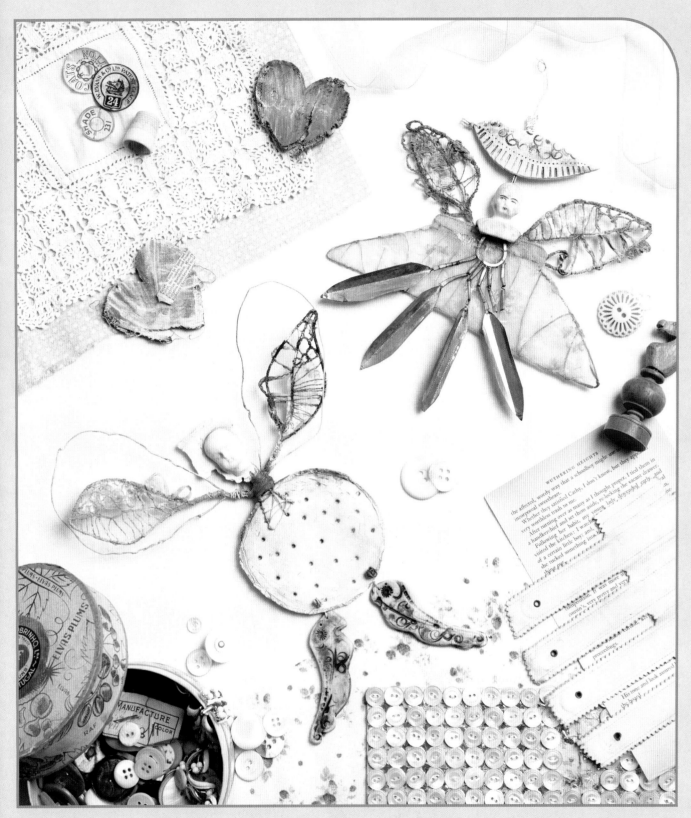

Curious Creatures

18 x 22cm and 19 x 23cm (7 x 8¹/₂in and 7¹/₂ x 9in)

Colour and style

My work has always been firmly rooted in textiles. Some of my earliest memories are connected with textiles, and I've always had a strong emotional link to fabric. I had a pale pink organza scarf that I carried everywhere with me up until the age of three – so not much has changed!

A fabric's quality can be familiar, evocative and engaging, it keeps us warm, provides comfort and communicates our personal taste to others. The language of cloth is ever constant and its enduring legacy is something that fascinates me – I couldn't imagine working with anything else.

Finding your style

Although I studied embroidered textiles, I've always employed a mixed media approach to my work and incorporated working practices from a range of other discipline besides textiles; including sculpture, ceramics and print. Collaging these elements together with textiles is what makes my work personal.

Gathering materials is a fundamental part of my practice. Fragments of the past prompt me to think about their history; it may just be a scrap of fabric or paper, a linen button or a broken brooch, but each has a unique story of its own. Everyday ephemera are easily overlooked but they are at the heart of all my work.

Try to find your own unique angle – this is key to creating and developing a personal voice. I would suggest that you start by looking closely at the themes that interest you and identifying the materials you want to work with. If you find deciding upon a starting point difficult, then try a process of elimination instead – gradually winnow down your options until you are left with just the materials and themes you are most excited about. Find a combination that works for you.

Colour is an important part of the process; it says a great deal about the mood and atmosphere of the work you create. Getting it right can be a journey in itself so it's good to experiment and play. Always mix your own colours when painting and, if dyeing fabrics, be sure to test out colours before making a piece of work.

I like to use a delicate colour palette as it reflects a nostalgic feel. This means contrast is very important to my style. As a result, adding stronger accents of colour to the things I make works well for me.

I don't believe there are any rules when it come to colour, but being aware of proportions and balance is essential – always reflect on a piece as it develops and make changes to refine the colour choices you make.

The colours used in these pieces are typical of the muted, pastel hues I favour. Fabrics, inks and other media can all be chosen or mixed to create the right combinations.

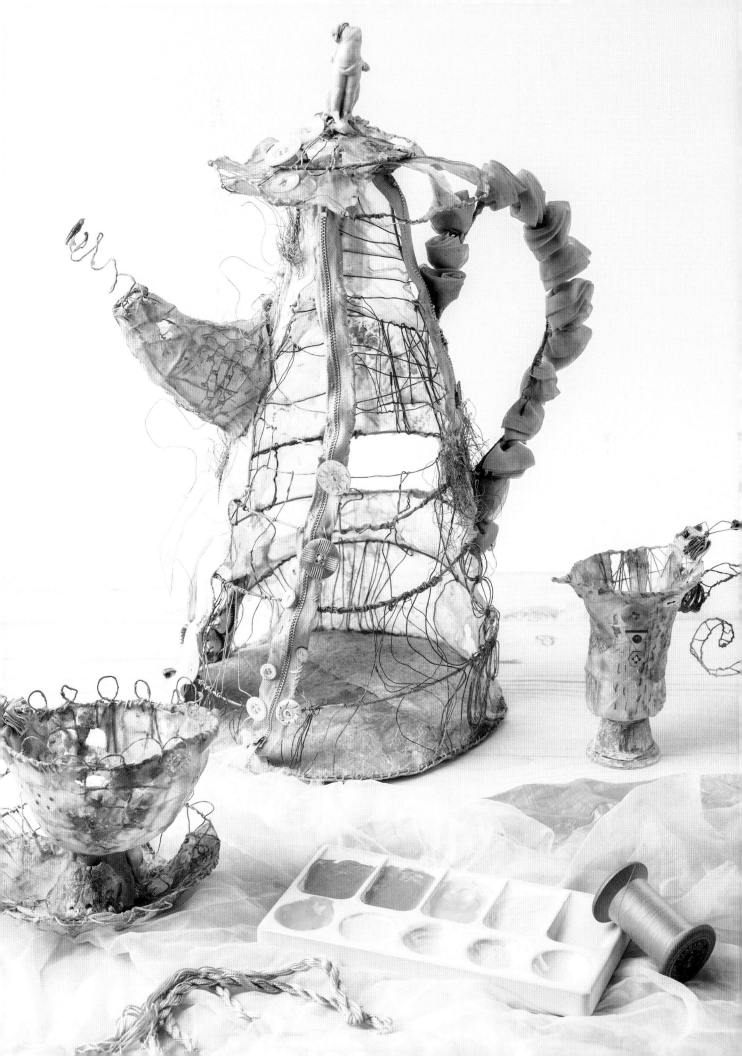

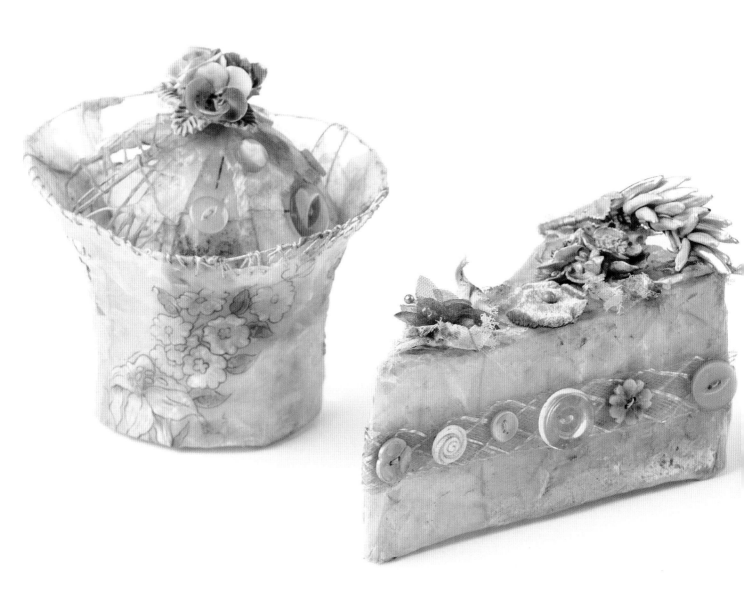

Afternoon Tea!

For this collection of tea-themed pieces, I have used a pale pink and blue. This palette evokes a nostalgic feel, reminiscent of afternoon tea in a summer garden. It creates a mood of refined decadence, when sipping tea and eating cake is all that should matter.

Choosing your colour palette

Colour can suggest mood, atmosphere and emotion; it can also bring harmony to a piece of work. Use your sketchbooks to experiment with colours wherever possible.

You can collage fabrics and papers from your scrap box to work out colour themes. Acrylic paints can also be mixed very easily to achieve your desired colour palette. Try adding paint to areas of wire that contrast or complement the colours used in your fabrics. Tone – lightness or darkness – is also very important, so if you are dip-dying your own fabric, consider making a variety of tones of the same colour to ensure you have access to the right shade.

Once a piece is complete, you can add embellishments to add to or enhance the colour. Stitching can highlight areas with an accent colour – a strong colour around an edging or to define a detail can be really effective. Punctuations of colour can be introduced with buttons, broken jewellery, lace, and fragments of paper or text. If you are lucky enough to find some vintage silk or velvet floral decorations these can add a lovely gesture of colour and texture.

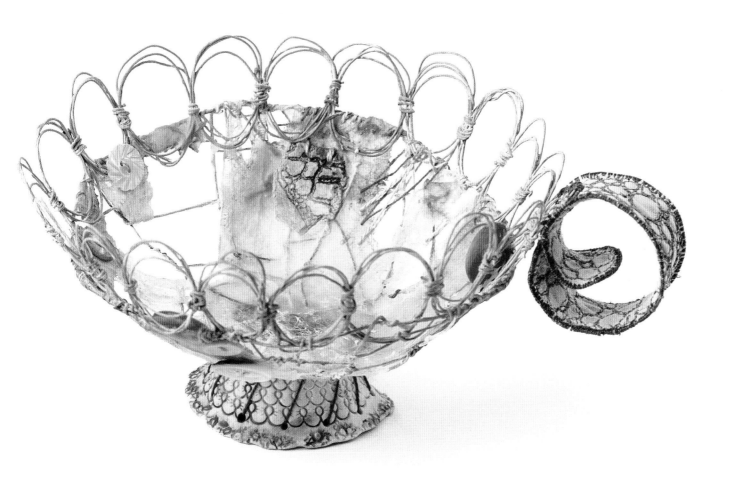

Theme, style and purpose

You should always follow your heart when it come to making work, don't put yourself under prescriptive pressures. To develop a style that opens up your personal voice, it's important to work around themes that inspire you.

There are a few common themes that run though my work: my fascination with domestic objects is a good example. Another reccurring theme is my passion for figurative pieces that focus on more conceptual themes. The one thing that binds all the work together is that my practice is always materials-led, this is what gives my work a style that's unique to me. When making your own work, consider what themes are of interest to you and carefully choose the materials you want to work with. Make choices based on previous experimentation. Finding your personal voice can take time so don't rush the process and continually reflect on your making.

When you make a piece, you should consider what the work is for. Is it functional or non-functional? The answer will inevitably steer you in a particular direction. As an example, I make functional, wearable pieces from time to time, and in these instances I do not use wax as it becomes very brittle when cooled: it will crack and flake easily if you bend it, making it too fragile to wear. All of the found materials I work with can be quite delicate, so wearable pieces take a little extra thought and planning, and are still usually for special occasions such as weddings rather than for everyday use.

It can be hard to balance aesthetics with practical use, but by adapting the right materials you can do both. The wearable piece opposite, *Spellbound*, is made from vintage lace, found objects and an old shirt collar, and looks stunning when worn over a simple linen dress. I made this piece a wire hanger to support the shape so it can be hung on the wall as a decorative piece when not being used.

My functional work is the exception, rather than the rule, as I find making purely decorative non-functional work so liberating. You can make absolutely anything – but you should still think about how it will be displayed as a final piece. If it's very fragile, you may need to protect it behind glass in a frame or under a glass dome. Wall-based work can be hung anywhere, but you still need to think about how it will attach to the wall. Because my work is created on an open wire frame it is easy to attach a small loop of extra wire or a short length of clear nylon thread to a piece allowing it to be hung on display. Three-dimensional pieces can of course sit anywhere.

My pieces are quite fragile having been made from rescued materials – but they can easily be repaired and reshaped if needed. I welcome the refashioning of work as it adds to the narrative of a piece and its alchemy. Fluctuations and flaws found in the pieces should be celebrated for their beauty and by loving them back to life I acknowledge their value.

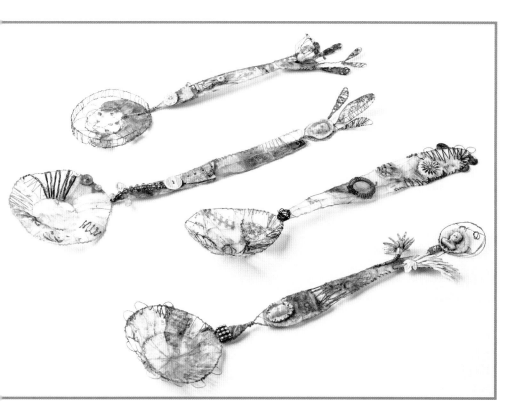

Loving Spoons

All 15 x 65cm (6 x 25½in)

I have collections of work based around assortments of spoons, teacups, teapots, accessories and clothing – the common theme for these non–functional pieces is the domestic sphere.

Spellbound

33 x 51cm (13 x 20in)

My figurative and wearable art pieces often focus on a concept or theme and are assembled from familiar materials and objects. I like to work with discarded and overlooked materials, they are unpredictable and capricious; usually imperfect but beautiful in equal measure.

Spellbound, the larger piece shown to the right, is a good example of a work that is driven by found materials; drawing together textures and shapes collaged into a wearable piece that rediscovers the loveliness of the lace, fabric and ephemera.

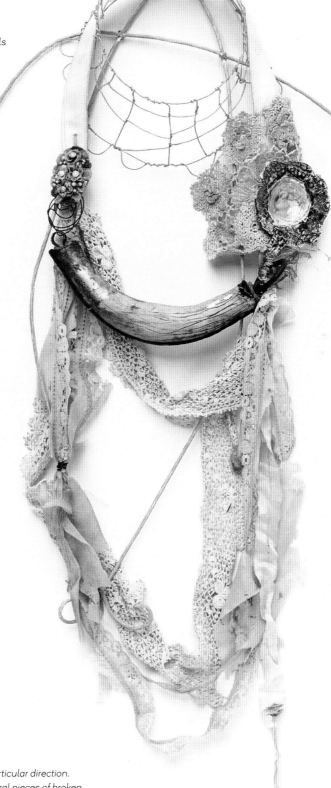

Dancer of Dreams

17 x 27cm (6¾ x 10½in)

A doll's head or a pair of china legs can steer a piece in a particular direction. Dancer of Dreams is a whimsical creature made from several pieces of broken weathered ceramics – she was quite challenging to make because there were so many components to fuse together. Her complexity makes her charmingly unique, I had a lot of enjoyment experimenting with different approaches to making her. Sometimes it can take many attempts to get something just right but when it works, how fabulous!

Lost and Found

This little figurative sculpture is made up of lots of found materials. In fact, the only part of the piece that has been manipulated by hand is the wire crinoline. It's a great example of the principles mentioned on pages 20–21, and how important it is to look for the potential in materials, and see past their original use.

Practicality and aesthetics are not opposed: something can be both attractive and functional. Here, the base is made from an old motorbike valve glued to a slim wooden reel. This allows the structure to stand firmly, but it also acts as a framing device, helping it to look attractive.

I wanted this piece to evoke a sense of reassembled overlooked objects. To achieve this, I used a darker colour palette to create a more melancholy mood.

The wings are made up of some rusty discs; this one had a cute star shape cut out from the centre – I liked the way this provided a negative space. I gave the wing a wash of white acrylic paint to soften the rust and then scratched into the surface to enhance the texture.

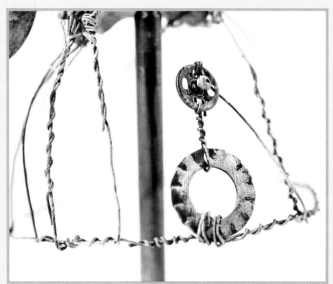

After working through some different ideas in my sketchbook, I decided to make the crinoline from wire, leaving wide gaps in between each strand to give it an open appearance. This strongly contrasts with the heavier structure of the metal wings. To balance this, I attached a vintage press-stud and a rusty washer to the front of the crinoline, which bring some of the focus away from the wings.

Around the reel I added a length of cotton tape and secured it in place with two entomology pins. The piece is finished with a coat of watered-down acrylic paint and some gold bronzing powder to give it a little touch of texture.

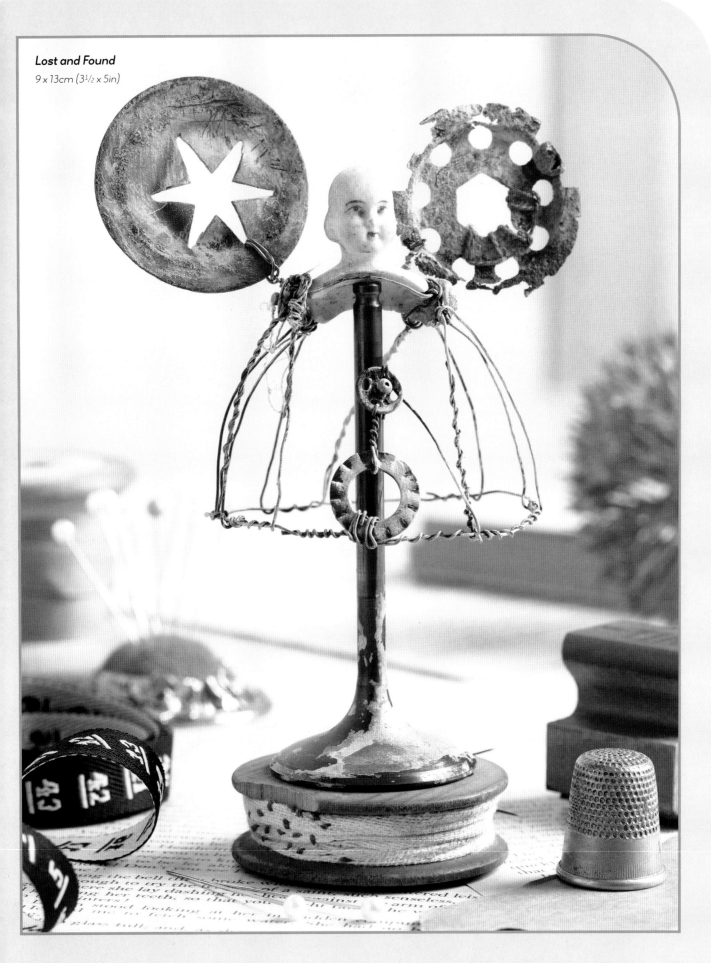

Sculptural textile projects

Here are five projects I have designed for you to try. Each one will show you how to create a finished piece based on the methods explored in the previous chapter. If you haven't already experimented with these techniques, I would suggest you go back and have a play before embracing the first project. This will give you the opportunity to get a feel for the materials and techniques used, and allow you to learn by exploration and practice. Each of these projects increases in complexity, enabling you to build up a range of skills as you progress, as well as giving you a selection of varied pieces ready to display. Do remember that all work made using wax should be treated with care: never put a piece in strong direct sunlight or next to a strong heat source. It may melt under extreme exposure to heat.

Please use all the following project ideas as suggestions. There are definitely no rules, and I would encourage you to bring your own ideas and working methods to the projects. Selecting materials is also a matter of individual choice, so trying out your own ideas is welcomed – this can also help you to develop your personal voice and style. Finally, don't be afraid to experiment when it comes to adding embellishments. Almost anything can be used; the more unusual, the better.

I hope by delving into the projects in this book you discover things you love, have fun bringing your own style and elegance to the ideas I've presented here, and find both a style that suits your soul and a purpose for making work that's about you.

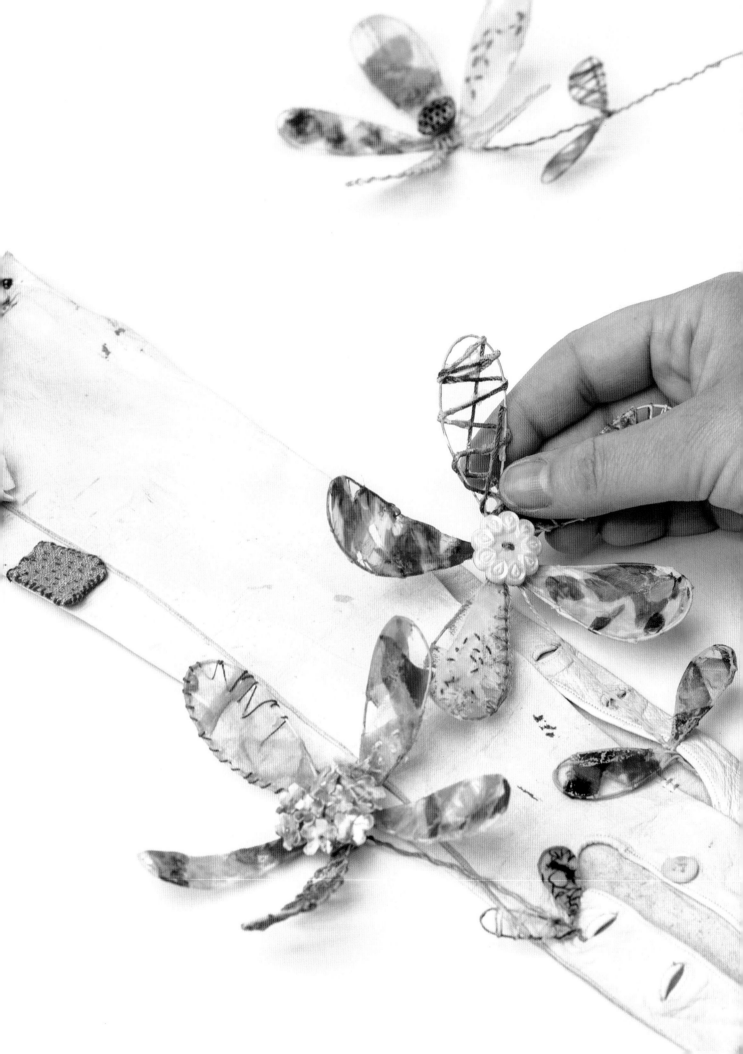

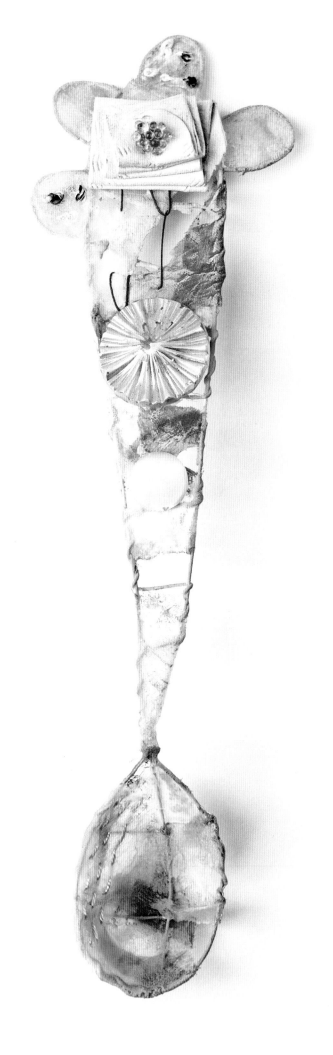

The finished piece
5.5 x 20cm (2¼ x 8in)

74

Souvenir Spoon

Spoons are lovely tactile objects, both decorative and useful. Souvenir spoons are especially interesting because they are so individual. Try to capture this individuality while making your own spoons, and focus on creating a distinct character for each one.

This is a great project for using up those tiny scraps of cloth you never know what to do with. It was inspired by a collection of souvenir spoons that belonged to my Great Aunt, and which I used to play with as a child – you can read more about the broader collection at the end of the project.

YOU WILL NEED

Pack of 24 gauge wire in 36cm (14in) lengths

Pack of 26 gauge wire in 36cm (14in) lengths

Grip pliers

Wire cutters

Prepared silks in a range of contrasting colours and tones

Small strip of leather

Artificial flower stamens

Embroidery needles and threads, including hand-dyed thread

Fabric scissors and embroidery scissors

Wax, batik pot and 12mm (½in) brush

Pins

Embellishments such as buttons and beads

Paints (acrylic and/or matt emulsion) and paintbrushes

Thick needle or awl

Superglue

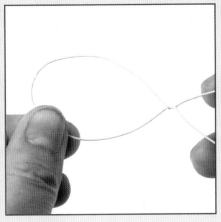

1 Take a length of 24 gauge wire and make a loop the size of a teaspoon bowl – approximately 3cm (1¼in) across. Twist below the loop to join it.

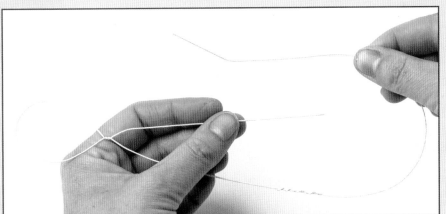

2 Join a new length of 24 gauge wire to one of the free ends, then curve the wire around to join the other free end.

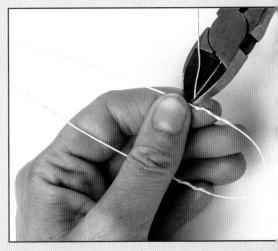

3 Join the length on, then use the wire cutters to trim the excess.

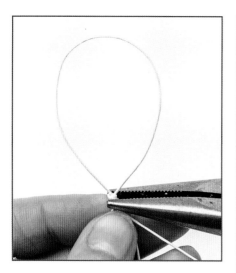

4 Join a length of 24 gauge wire at the neck of the spoon. It can be awkward to get your fingers in here to pinch, so you may want to use your pliers to crimp the wire.

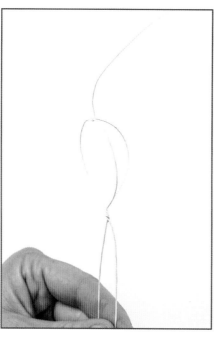

5 Make a curve to create the bowl of the spoon and join the wire to the top as shown.

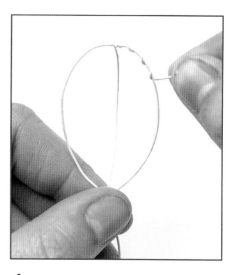

6 Wrap the end of the new wire roughly a third of the way along the original loop.

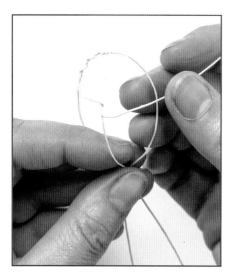

7 Take the wire to the bottom of the bowl of the spoon, wrap the wire here once, then take it up to the opposite edge of the original loop. As you work, shape the curve of the spoon with your fingers.

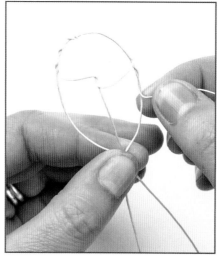

8 Wrap the wire down a further third of the loop.

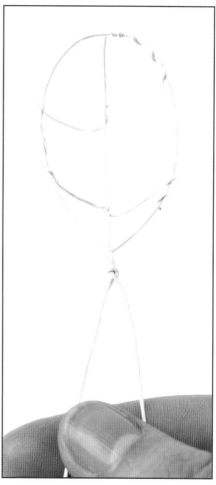

9 Take it down to the bowl, wrap once, then continue up to the opposite side once more. Wrap to secure the end. Trim any excess with the wire cutters. This completes the basic structure.

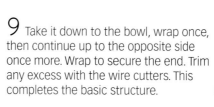

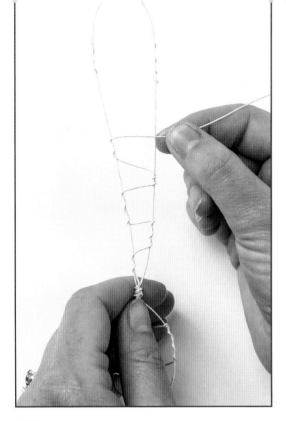

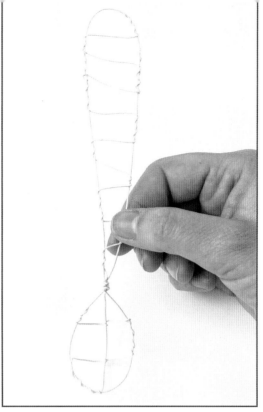

10 Take a length of the 26 gauge wire and join it at the neck of the spoon, then begin to create a sinuous pattern up the handle. This is worked in the same way as the wire across the bowl of the spoon in steps 6–9.

11 Try to keep the spacing roughly even between each loop, and work to the end, wrapping the last 5cm (2in) or so of the wire to finish. Depending on how large you've made the loops, you may need to trim a little excess.

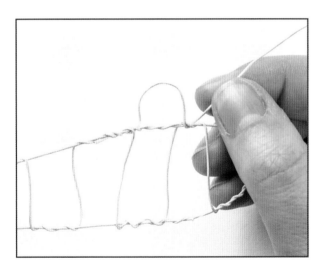

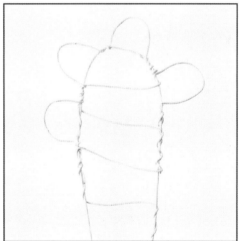

12 Attach another length of 26 gauge wire where the end of the handle was attached in step 2, create a small loop, and wrap it back on as shown.

13 Work around the end of the spoon, creating a series of loops. Trim the excess.

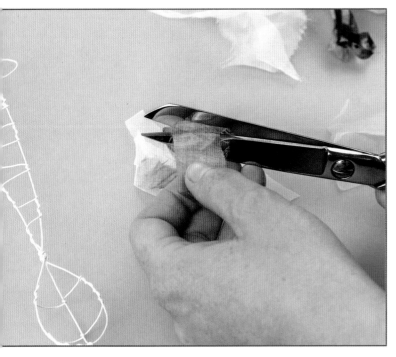

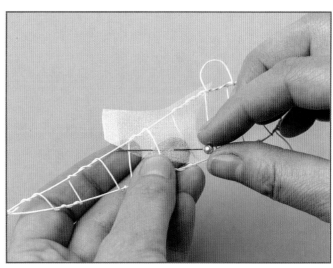

15 Pin your first piece of fabric to the spoon; it doesn't make a huge difference where you begin.

14 Put down your protective mat and while the batik pot warms up, cut your fabrics into small, variably-shaped pieces, each roughly 2cm (1in) across.

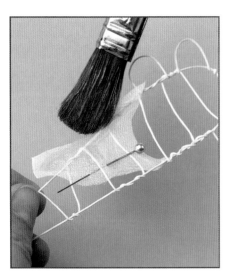

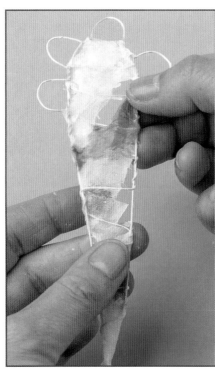

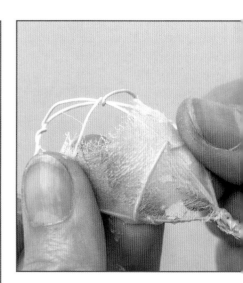

16 Working along the wire, apply wax to secure the fabric as described on page 36.

18 When adding fabric to the bowl of the spoon, bear in mind you're creating a curved form. Use your fingers to ease the surface of the material into the right shape.

17 Continue building up the fabric over the wire, introducing colours and leaving gaps.

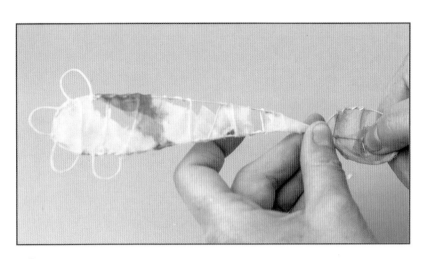

19 Leaving gaps in a curved form can leave things looking too open; but covering it entirely will restrict the embellishments you can add later. Aim to leave a few small gaps – enough to add air and light, but without compromising the impression of the curved bowl shape.

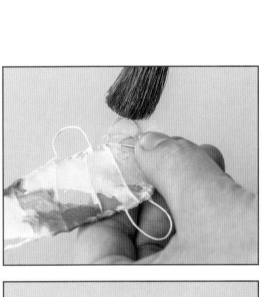

20 When covering the decorative loops at the end of the handle, you probably won't need to add fabric to both front and back; you will find you can simply use a small piece to wrap round completely.

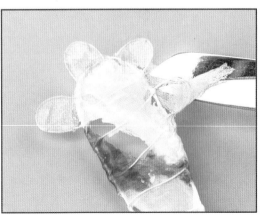

21 If a piece of fabric is too large, wait for the wax to cool and trim away as much as you need, using your scissors. This completes the fabric stage (see image, right).

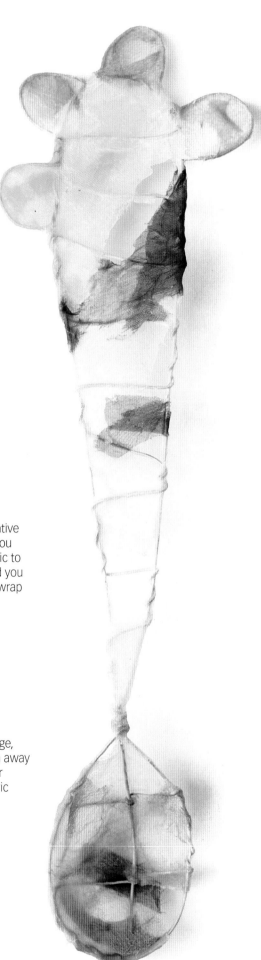

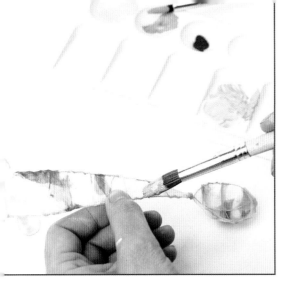

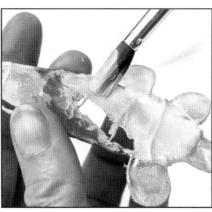

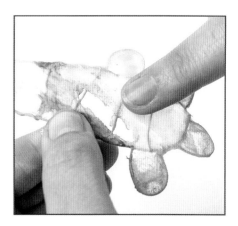

22 Paint any wire that remains exposed, using colours that complement or contrast with the colours in your fabric. Don't worry if a little paint goes on the fabric – we're going to add touches here and there anyway!

23 Use the brush to lightly paint over covered areas that you want to highlight. Areas near a gap or that have lots of covered wirework are good spots.

24 Use your finger to blend the paint away; this helps to bring out the texture of the fabric and ensures you don't cover the colours completely.

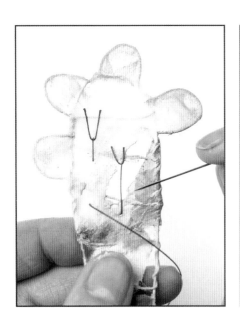

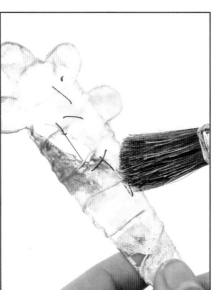

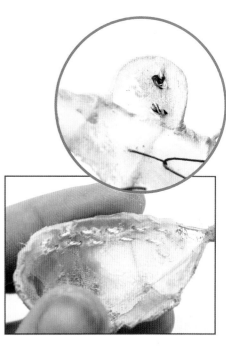

25 Thread a needle with your desired thread and begin to work some surface embroidery, starting with a knot to hold the thread in place. The exact stitching is down to you, and will be influenced by the fabrics and gaps in your piece. Here I'm making a few fly stitches on the handle – note that I'm working straight over a gap here.

26 At the end of the line of stitches, rather than making a holding stitch, trim off the thread on the back and use wax to secure the thread.

27 Hand stitching is an ideal way of personalizing your work, so feel free to embellish as you wish. Here, for example, I've made a line of running stitch along the rim of the bowl of the spoon and a cluster of French knots on one of the loops on the handle, using some hand-dyed thread. How much stitching to add is down to you, but bear in mind that the stitching is intended to highlight and enhance areas of the spoon's fabric and structure, rather than overshadow it.

28 Fold the strip of leather into a concertina, slightly reducing the size of the folds as you go.

29 Punch a hole in it using a thick needle or awl, and thread an artificial stamen through to hold it together.

30 Coil the excess wire to secure the false stamen.

31 Glue the embellishment in place at the top of the spoon, then stitch on a button or two – or other embellishments – to finish. A larger image of the finished spoon can be seen on page 74.

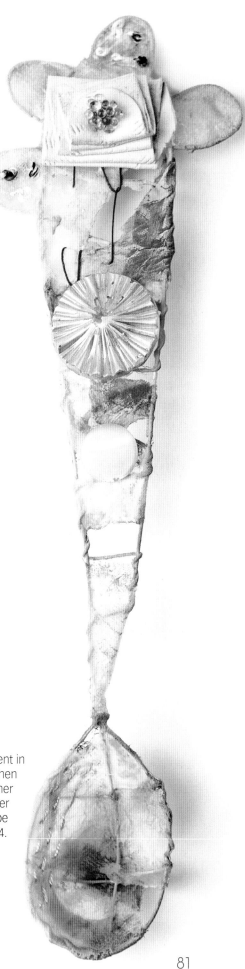

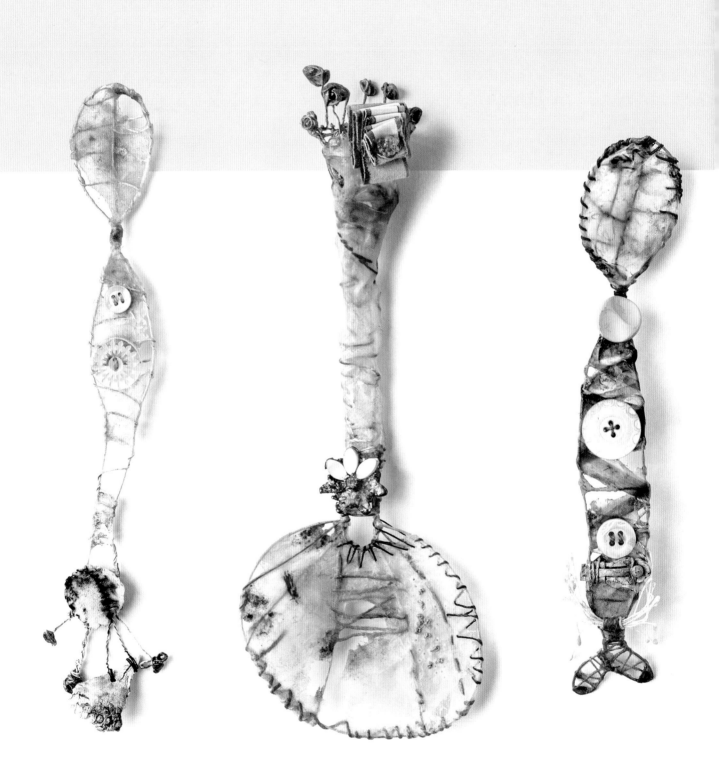

Souvenir Spoons collection

A range of sizes from 3 x 15cm to 8 x 23cm (1¼ x 6in to 3 x 9in)

I adore making spoons – they are just delightful. Charmingly tactile, they feel nice simply to handle as we stir our tea and measure our sugar. As practical utensils they can be overlooked, but as decorative items they can be highly valued. Memories of my Great Aunt's collection of souvenir spoons make them special for an entirely different reason for me. She told me that she had bought one from every place she visited and it reminded her of happy days exploring the world. The spoons connected her to places that she loved, each spoon as individual in character as the place she had visited. I tried to capture this theme while making my collection, and focused on creating a distinct personality for each one.

My Great Aunt was very special to me and, like her spoons, she had lots of character too. I spent masses of time with her as she loved making and creating, and passed that passion for textiles to me. Auntie was a great recycler and some of the fabric and haberdashery she gave me has been added to my own work over the years. She showed me the possibility that every fragment of disintegrating fabric could be repurposed – and she was right!

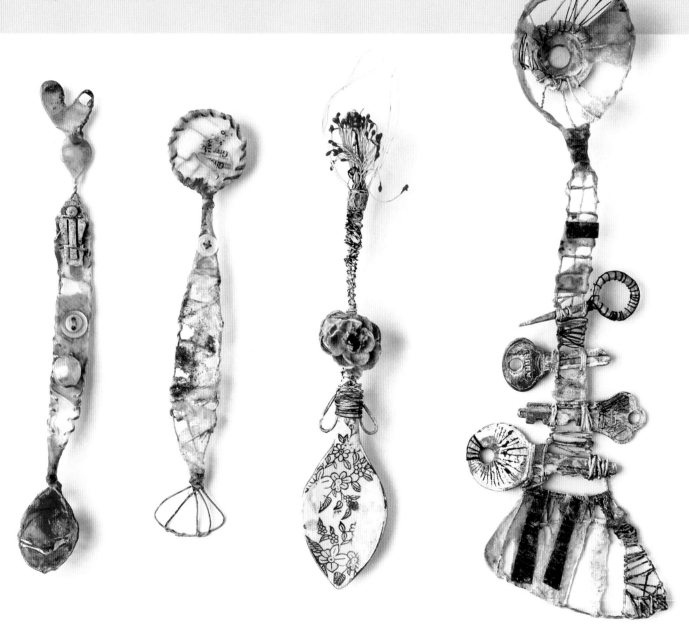

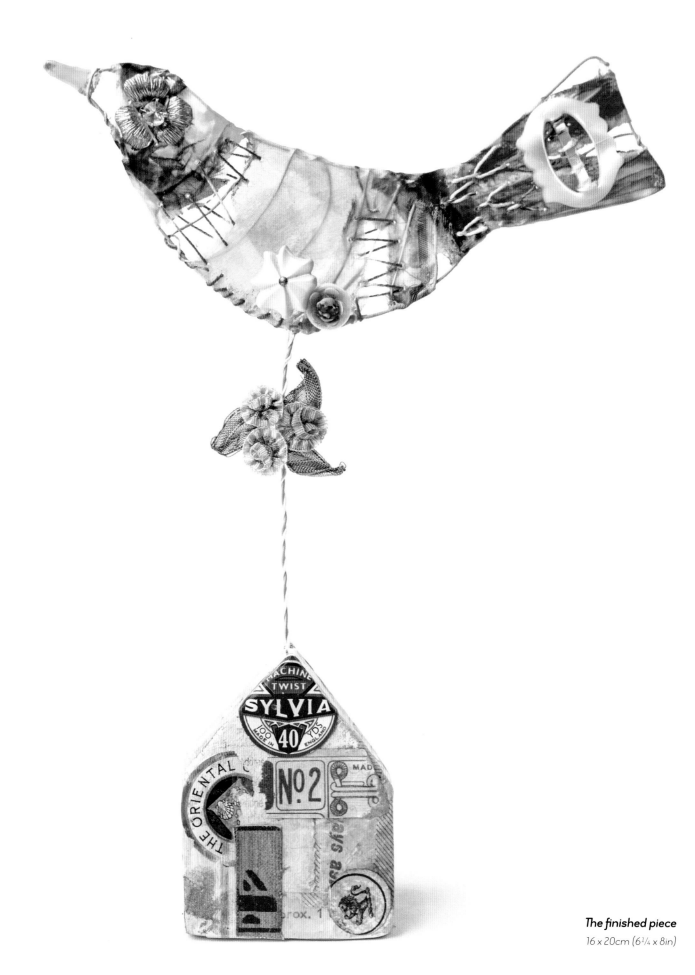

The finished piece
16 x 20cm (6¼ x 8in)

Fly Away Home

You can have fun with this project by experimenting with different combinations of plain and patterned fabrics to give yourself a bit more of a challenge and a more interesting and complex finish. Think about the mood you want to create, perhaps referring back to previous experimentation or sketchbook ideas. I recommend you choose a mixture of stronger contrasting fabric and thread colours to explore the possibilities of different colour combinations.

If you want to copy this shape exactly, a template is provided on page 128 (extra copies of the template are available from www.bookmarkedhub.com) to help guide you, but I encourage you to have a go at shaping your own bird, too.

YOU WILL NEED

Pack of 24 gauge wire in 36cm (14in) lengths

Pack of 26 gauge wire in 36cm (14in) lengths

Grip pliers

Wire cutters

Prepared silks in a range of contrasting colours and tones

Embroidery needles and threads, including hand-dyed thread

Fabric scissors and embroidery scissors

Wax, batik pot and old brush

Pins

Embellishments, such as buttons and beads

Paints (acrylic and/or matt emulsion) and paintbrushes

Superglue

PVA

Air-drying clay, knife and metal kidney

Awl

Found or vintage papers, such as cotton reel labels or old button cards

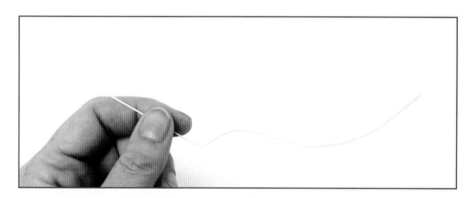

1 Take a length of 24 gauge wire to make the outline of the bird. Start at the base of the bird's stomach and make a curve for the bird's breast and neck, then angle out for the beak. Refer to the template on page 128 to help guide you.

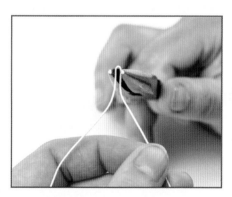

2 Make a sharp angle for the tip of the beak using the grip pliers.

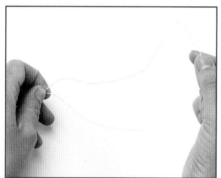

3 Continue working round the shape, creating the curve of the bird's body and a sharper angle at the tail.

4 Continue the tail shape, joining a second length of wire. Bring the body to a close where you started, securing it at the join.

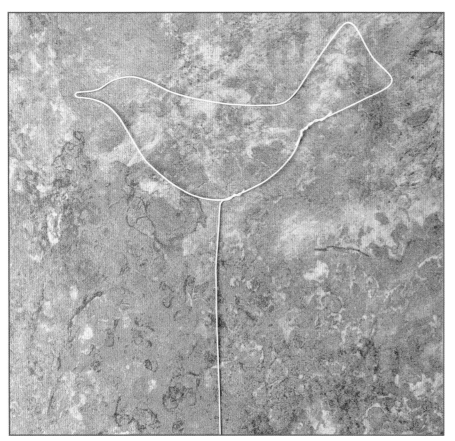

5 Use the rest of the new length to make a long upright perch.

6 Join a length of 26 gauge wire below the bird's beak. Take it over to the top of the beak.

7 Continue winding the new wire to describe the contours of the bird's head.

8 Continue building up structure and support for the fabric by working the wire over the body, excluding the tail. Most of this will be covered later, so concentrate on making sure that the gaps between the wire are close enough – these here are approximately 1cm (½in) between.

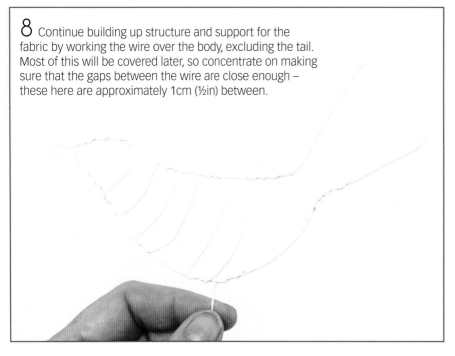

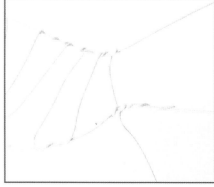

9 Join a new piece of 26 gauge wire and work to the base of the tail in the same way.

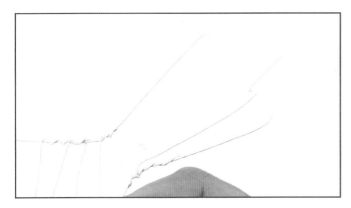

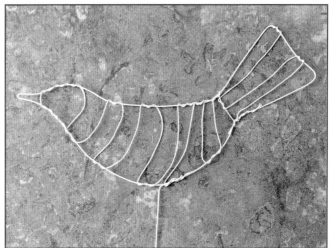

10 For the tail, work in the same way but at right angles, to create the impression of longer feathers. Wind the wire around the wire at the base of the tail (see step 9), and use the wire cutters to trim any excess.

The wire frame stage is now complete.

TIP

The exact shape of the bird is up to you – here are a few other examples to provide some ideas. The tail, in particular, is a good place to bring in different shapes in your wire structure.

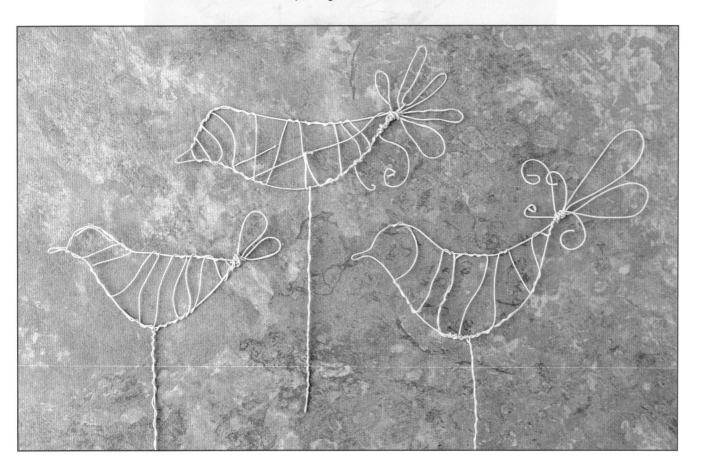

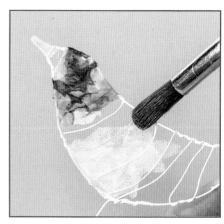

11 Set up your batik pot. While the wax melts, select your fabrics and trim them into small pieces and strips.

12 Place a mat on your working surface to protect it, then use the old brush to apply the wax to a piece of fabric and begin to build up the bird. I'm starting from the beak and working towards the tail, but you can start anywhere.

13 Continue building up the fabric on the wire, leaving some small gaps as you go.

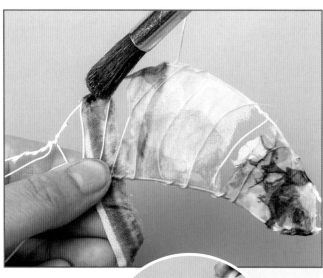

14 Strips of fabric are great for leaving tiny gaps as they are wound around the wire, particularly on smaller pieces. When applying the strips, start by securing one end: wrap the end of the strip round the wire and apply the wax to hold it in place.

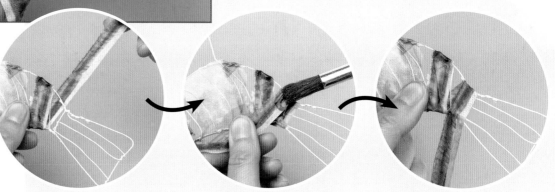

15 Pull the strip taut – be gentle, or you risk pulling it off the wire – and wind the strip back and forth across the structure, brushing on wax as your go. Concentrate on adding wax to areas with the wire structure directly beneath.

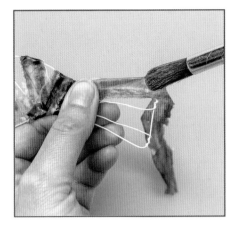

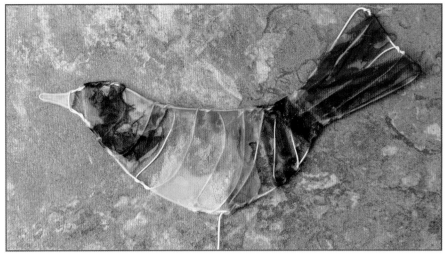

16 When adding fabric over the tail, following the lines and direction of the wire can help to reinforce the impression of long trailing feathers, creating a more naturalistic finish.

The fabric application stage is now complete.

17 Use a small brush to add some touches of paint to exposed areas of wire, including the perch. Use colours that complement or contrast with the fabrics so that it stands out.

18 As the paint on the brush starts to run out, lightly draw the brush over some areas of the fabric with underlying wire to use what remains. While the paint is wet, smudge it away with your finger to highlight the wire structure.

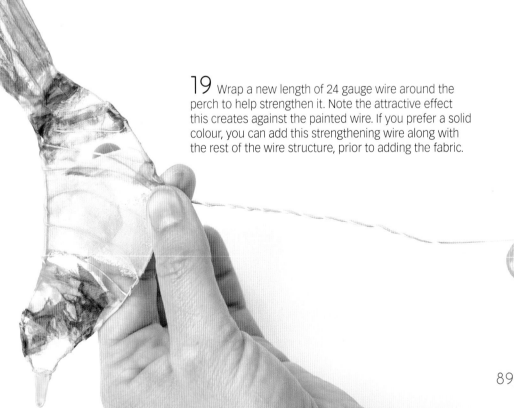

19 Wrap a new length of 24 gauge wire around the perch to help strengthen it. Note the attractive effect this creates against the painted wire. If you prefer a solid colour, you can add this strengthening wire along with the rest of the wire structure, prior to adding the fabric.

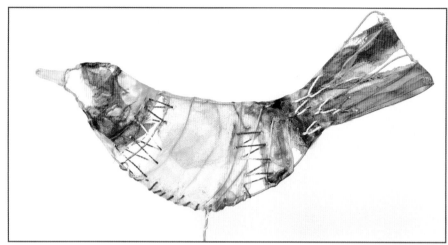

20 Thread a needle with your hand-dyed thread, knot the end, then use bridging whip stitch to cover larger gaps and visually join the parts of the bird.

21 Continue to add embroidered details to your bird. I've added whip stitch along the breast and belly, and fly stitch on the tail. Use a spot of wax to secure the ends of the threads.

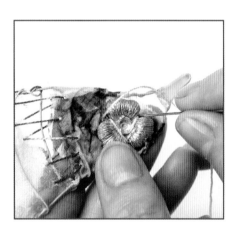

22 Begin to attach your chosen embellishments. Here I'm attaching an attractive flower-shaped trinket by running long stitches over and between the petals.

Attaching embellishments

Since the embellishments you use will depend upon what you've got to hand, you may need to use stitching or superglue – or other methods – to attach them securely. In general, I recommend using stitch unless glue is absolutely necessary, as stitching is both decorative and permanent: even the best glues can eventually fail.

For these reasons I have attached all the embellishments with stitch, with the exception of the centre of the bird's eye, which was glued in place. You can use a simple stab stitch to secure most things.

I used a bridging whip stitch to fill in the gaps between the edges of the waxed fabrics; I have also added a small cluster of fly stitches on the bird's tail.

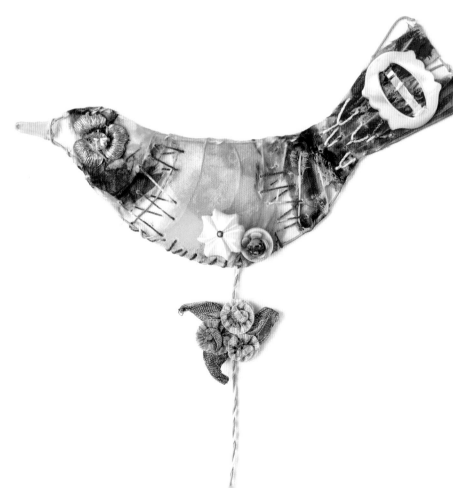

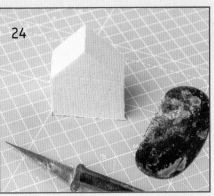

23 Protect your surface with a waterproof cutting mat (this protects the surface and also prevents the clay drying out too quickly). Use the metal kidney to cut out a rectangle of air-drying clay measuring 5 x 7.5cm (2 x 3in).

24 Use the knife to trim the block down to a small, simple birdhouse shape.

25 Use your fingers to smooth the surface, then use the awl to make a hole in top – take it down to roughly halfway into the house. Allow the clay to dry completely before continuing.

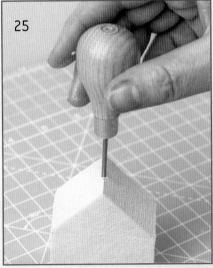

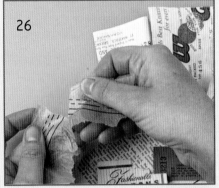

26 Still working on your waterproof surface, select some papers with which to collage the birdhouse. Tear the paper into small, irregular pieces – roughly 2cm (¾in) in size.

27 Water down a little PVA glue and use this with a brush to begin to collage your birdhouse.

28 Once dry, use a little watered-down white paint to work over the surface, and gently rub it away with your finger. This knocks back the text on the paper a little bit, creating a subtler, more interesting finish.

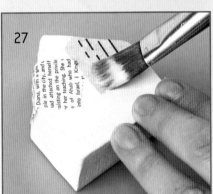

TIP

You can use any sort of paper for collaging the birdhouse – but I suggest you keep the paper reasonably lightweight to make it easier to manipulate.

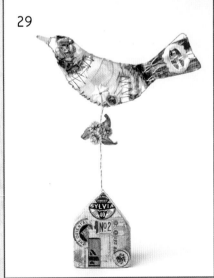

29 Once dry, insert the perch of the bird into the hole in the birdhouse to finish. A larger picture of the finished project can be seen on page 84.

91

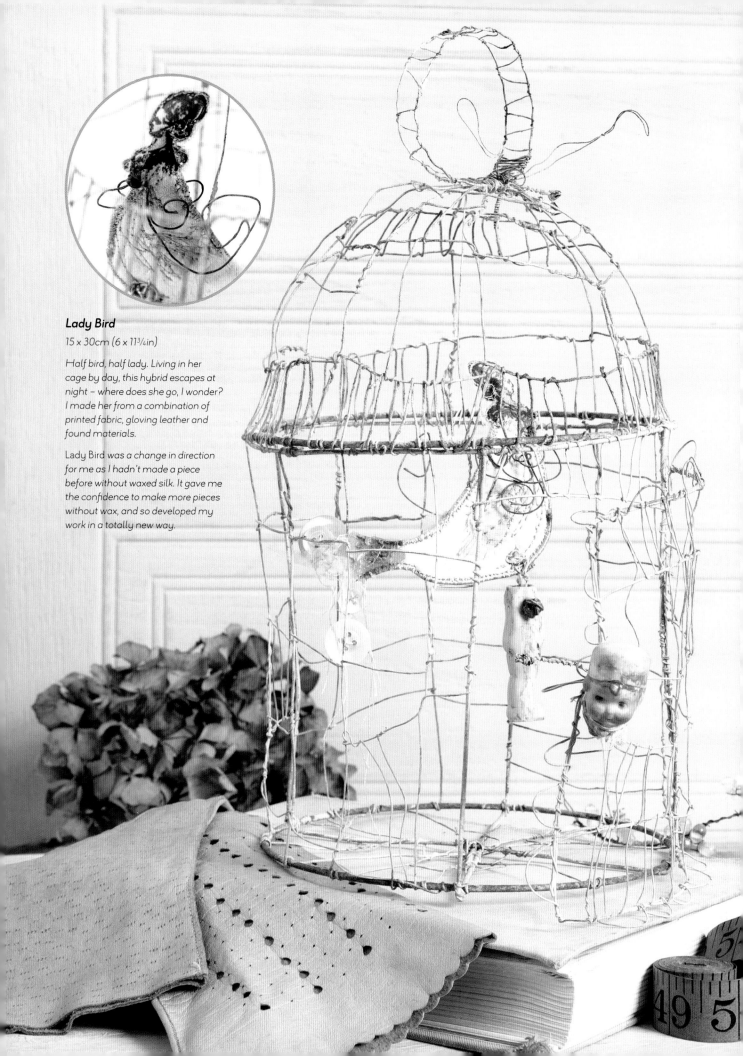

Lady Bird

15 x 30cm (6 x 11¾in)

*Half bird, half lady. Living in her
cage by day, this hybrid escapes at
night – where does she go, I wonder?
I made her from a combination of
printed fabric, gloving leather and
found materials.*

*Lady Bird was a change in direction
for me as I hadn't made a piece
before without waxed silk. It gave me
the confidence to make more pieces
without wax, and so developed my
work in a totally new way.*

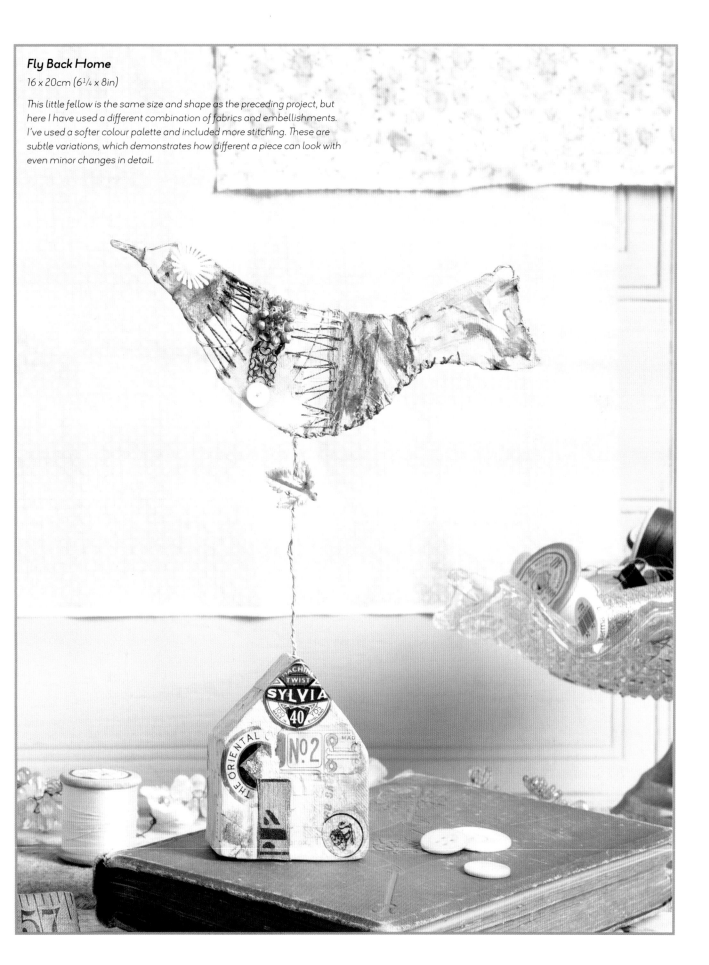

Fly Back Home
16 x 20cm (6¼ x 8in)

This little fellow is the same size and shape as the preceding project, but
here I have used a different combination of fabrics and embellishments.
I've used a softer colour palette and included more stitching. These are
subtle variations, which demonstrates how different a piece can look with
even minor changes in detail.

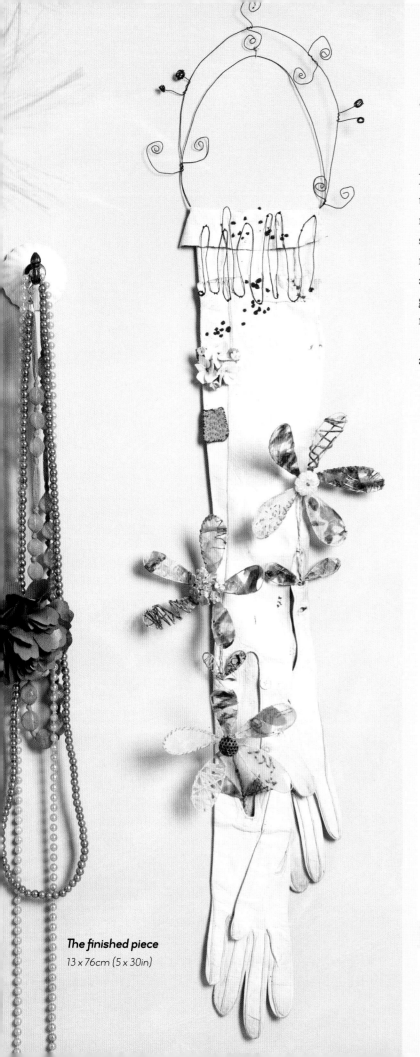

The finished piece
13 x 76cm (5 x 30in)

A Pocket Full of Posies

I love making flowers. There are so many beautiful textures, shapes and details in their organic forms, making them perfect inspiration for both wire and stitch. For me, creating the pale delicate petals is the most transfixing part of the process, though I also adore stitching into the shapes. These flowers look great grouped together and really cheer a corner of the room on a cold gloomy winter's day.

This project uses the tiniest pieces of silk, and so it is a great way to use those last scraps of favourite fabrics.

YOU WILL NEED

Pack of 24 gauge wire in 36cm (14in) lengths
Pack of 26 gauge wire in 36cm (14in) lengths
Coil of 24 gauge black iron wire
Grip pliers
Wire cutters
A small selection of prepared silks in a range of contrasting colours and tones
Embroidery needles and threads, including hand-dyed thread
Fabric scissors and embroidery scissors
Wax, batik pot and old brush
Pins
One or two larger embellishments, such as brooches or large decorative buttons
Paints (acrylic and/or matt emulsion) and paintbrushes
Superglue
Long-sleeved gloves with buttonholes – I've used a vintage kid leather pair

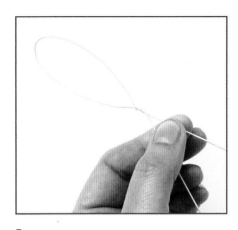

1 Using a length of 24 gauge wire, prepare a petal shape in exactly the same way as for the leaf shape on page 30.

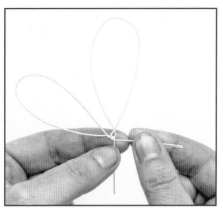

2 Using the length of wire remaining, make a second petal the same size as the first and secure the ends together in the centre. Do not trim the ends.

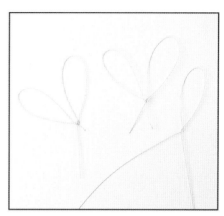

3 Make another pair of petals in the same way, then make a fifth lone petal, leaving a long tail as shown.

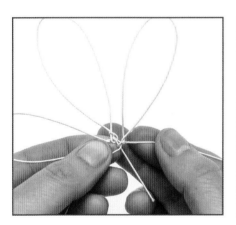

4 Place the single petal on top of the ends of a double petal, and use the shorter end of the single petal's wire to bind it to the centre.

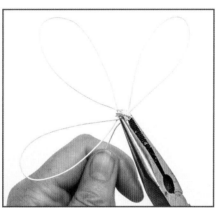

5 Leaving just the longest length as the stem, wrap the other ends from both pieces into the centre, creating a central ball of wire. I recommend giving it a gentle pinch with your grip pliers to tighten and secure the ball – avoid flattening it entirely, as you will need to thread a needle through it later to secure the focal embellishment.

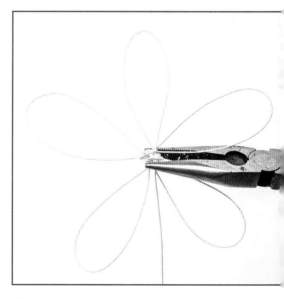

6 Attach the other pair of petals, wrapping the ends in the same way. Wrap the excess wire around the central ball rather than cutting any ends off.

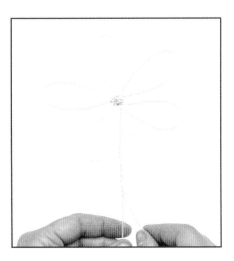

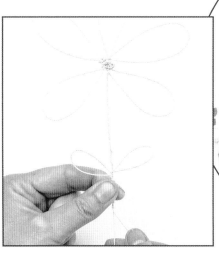

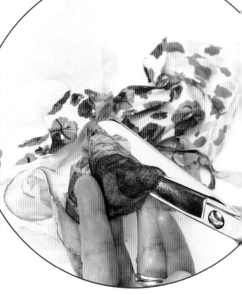

7 Join another length of 24 gauge wire onto the stem to strengthen and extend it. Wind it down for 5cm (2in) or so.

8 Use the new length of wire to loop out and make a leaf. Wrap it round the stem and do the same on the other side, then continue wrapping until you run out of wire.

9 Set up your batik pot and, while it warms, select your fabrics. You'll only need a small amount for these flowers.

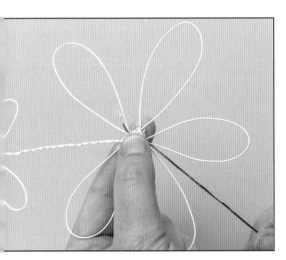

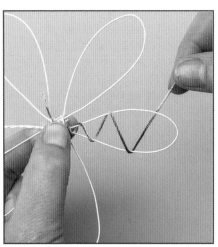

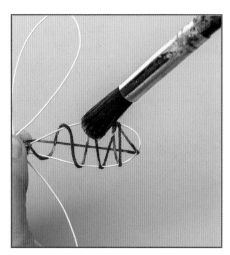

10 Cut a 45cm (18in) length of hand-dyed thread. Hold it on the ball at the centre of the flower using your thumb, with a little end free.

11 Holding the end in place, carefully wrap the thread round the petal.

12 Wind it back to the centre, then hold it taut with your thumb while you use the brush to paint wax over the whole petal – wire, thread and all!

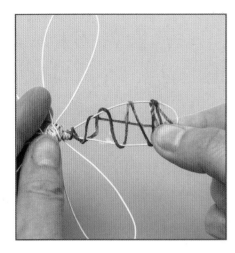

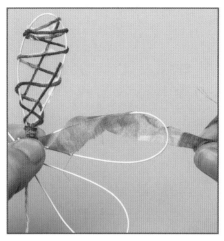

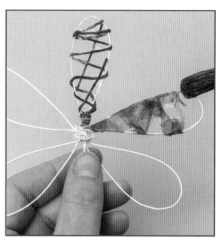

13 Leave it a moment or two for the wax to begin to cool. Before it sets, use your fingers to pinch the whole petal to set the wax, thread and wire together firmly.

14 Wrap a strip of fabric around the next petal, leaving a few small gaps.

15 Secure the strip with wax.

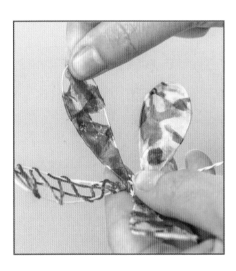

16 Continue to decorate the other petals – I wrapped the remaining petals for my flower with strips of fabric. Once the wax has set, give the petals a gentle curve to give them some form and dimensionality.

17 Decorate the leaves in the same way as the petals.

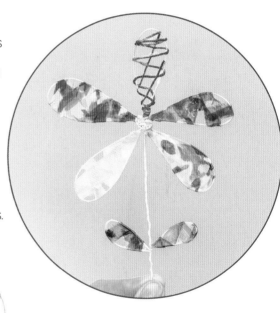

18 Clear away your batik equipment, gather your paints and tools, then paint the exposed wire with harmonizing or complementary colours. Use your finger to smooth paint over and off the surface to highlight the texture and underlying wire structure.

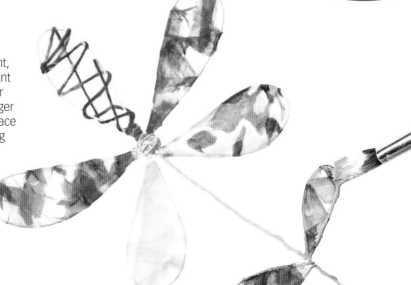

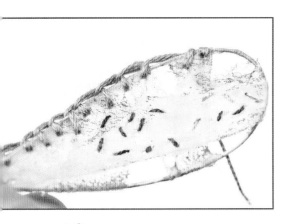 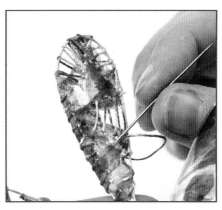 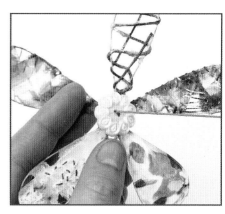

19 Thread a needle and tie a knot in it; then begin embellishing the work with embroidery. I've added some buttonhole stitch to the edge of one of the petals, then developed the same petal further with seed stitch.

20 Add some bridging whip stitch (see page 49) to work over the gaps in one of the other petals. When you finish, take the thread down and through the central ball to secure it.

21 Secure a focal embellishment to the central ball. A decorative button is a great finishing touch to a flower, and can be secured by working the needle through the central ball from the back.

22 This completes one flower. You'll need three for the full project. You can make them as varied as you choose, but I suggest that you keep some common features to ensure they all hang together well. Here, I've kept the number and shapes of the petals on each flower consistent, and used harmonious colours on each.

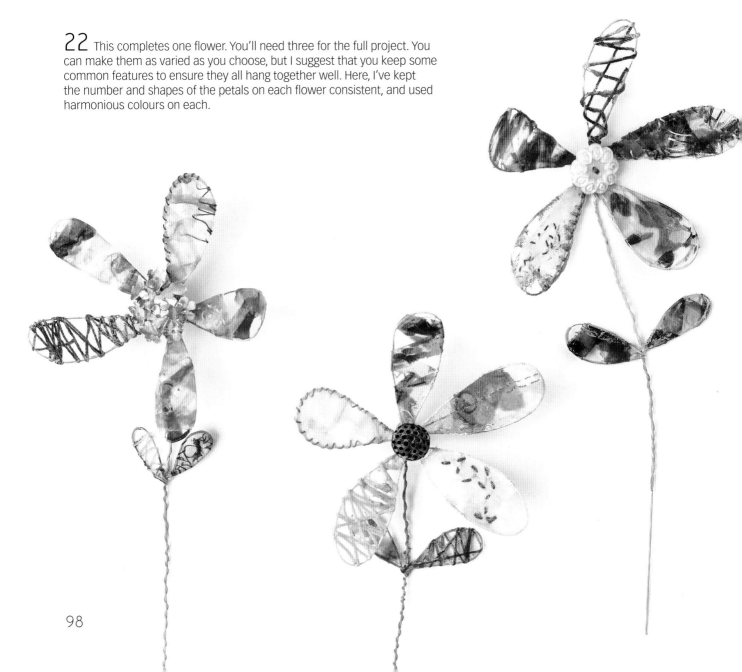

23 Cut a 92cm (36in) length of black iron wire from the coil. Shape it into a loose handle shape, by folding it in half, then making one sharp kink 5cm (2in) or so from the halfway point. Curve the rest of the folded wire gently, then make another sharp kink to mirror the first.

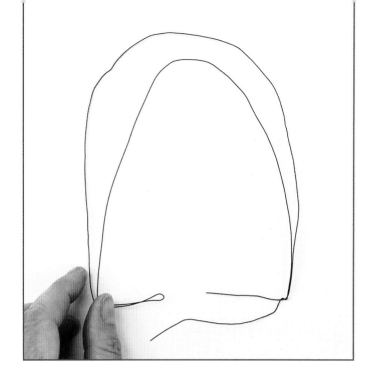

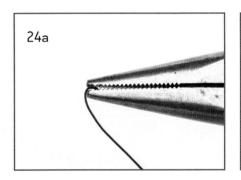

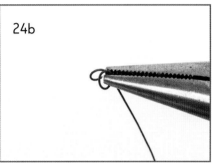

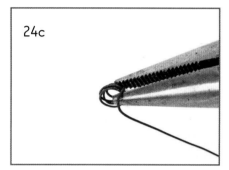

24 Cut a short length – approximately 15cm (6in) – of black iron wire and grip the very end with your grip pliers. Holding the pliers steady, gently curl the end over by turning the wire. Continue winding the wire round, creating a tight curl of wire. Twist and vary the angle as you work to curl the wire into a ball.

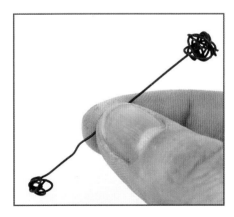

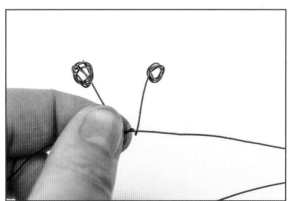

25 Leave a gap of 5cm (2in) or so, then repeat on the other end and trim any excess.

26 Join the middle part of this wire embellishment to the top (the centre of the curved part) of your handle by winding it around the wire of the handle here.

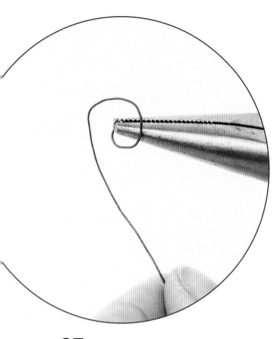

27 Make some curlicues by curling short lengths of wire more loosely. Leave them flat, rather than twisting them into balls.

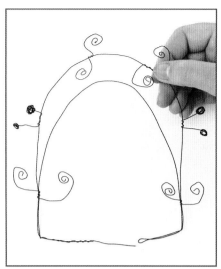

28 Decorate your handle with a variety of these wire embellishments. Don't decorate the loose ends at the bottom; these need to be left clear.

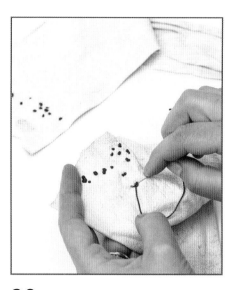

29 Add some French knots to the cuffs of your gloves using a contrasting colour thread.

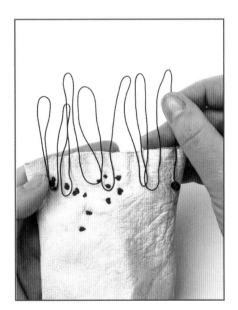

30 Cut another 92cm (36in) length of black iron wire and curl the ends into balls (see step 24). Fold the wire repeatedly into a concertina roughly the same width as the cuff of the gloves. This will be used as a joiner to attach the two gloves together.

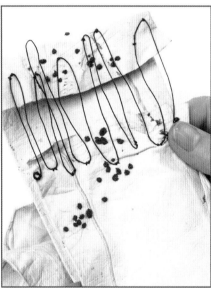

31 Use black thread to secure the concertina joiner to both gloves; joining the pair at the cuffs, while leaving an attractive gap between them.

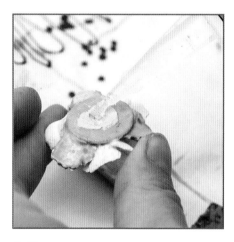

32 Add one or two striking embellishments along the front arm area of the glove to lead the eye from the joiner down to the buttonholes near the wrist, where the flowers will sit. I've used superglue to attach a vintage floral brooch, and also a small piece of fabric which I embroidered with whip stitch and running stitch in a contrasting thread.

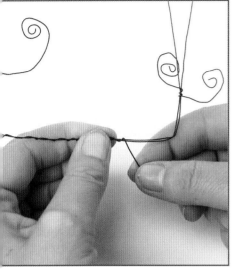

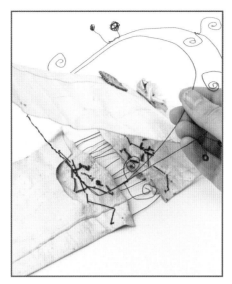

33 Test fit the gloves on the handle, then join the loose ends of the handle (see step 28) together, ensuring it remains slightly wider than the width of the gloves.

34 Lay the paired gloves down, then carefully thread one glove through the centre of the handle as shown.

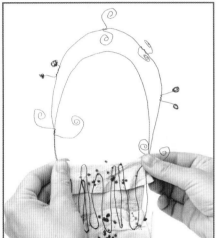

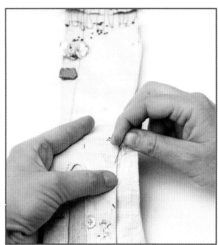

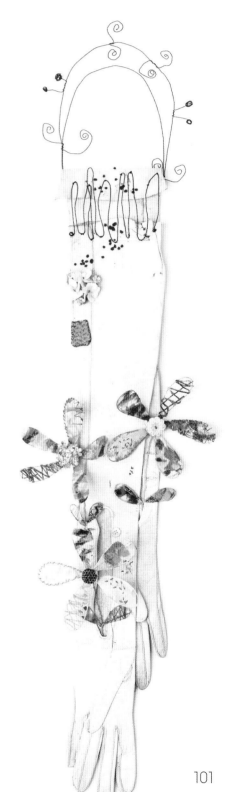

35 Fold the gloves so the concertina joiner is visible from the front, a short distance below the bottom of the handle.

36 Using a thread that matches your gloves, make a few small holding stitches to secure the gloves together at the bottom.

37 Arrange the flowers within the gloves to finish. A larger picture of the finished project can be seen on page 94.

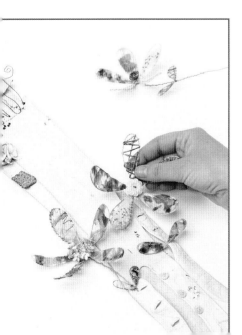

101

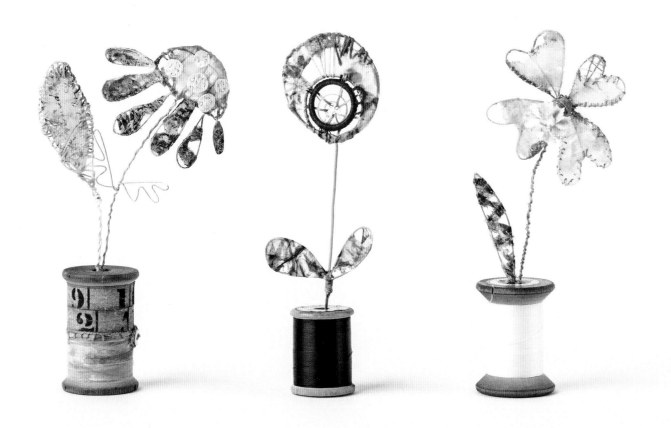

How Does Your Garden Grow?

A range of sizes from 7 x 14cm to 9 x 24cm (2³/₄ x 5¹/₂in to 3¹/₂ x 9¹/₂in)

My little collection of flowers was inspired by a day out drawing; in this case at wonderful Levens Hall in Cumbria. I try and go out on drawing days as often as I can, it is wonderful spending time filling up my sketchbooks with new ideas to stimulate creative thinking.

The formality of the gardens at Levens Hall suggested so many ideas. I chose to focus on the simplicity of the stylized shapes I had been sketching. The result was a collection of delicate flowers and foliage, which I then fixed into vintage wooden cotton reels. This builds on the idea of up-cycling. The great beauty in making small-scale sculptures is you can make many variations on the same theme and they look fabulous grouped together.

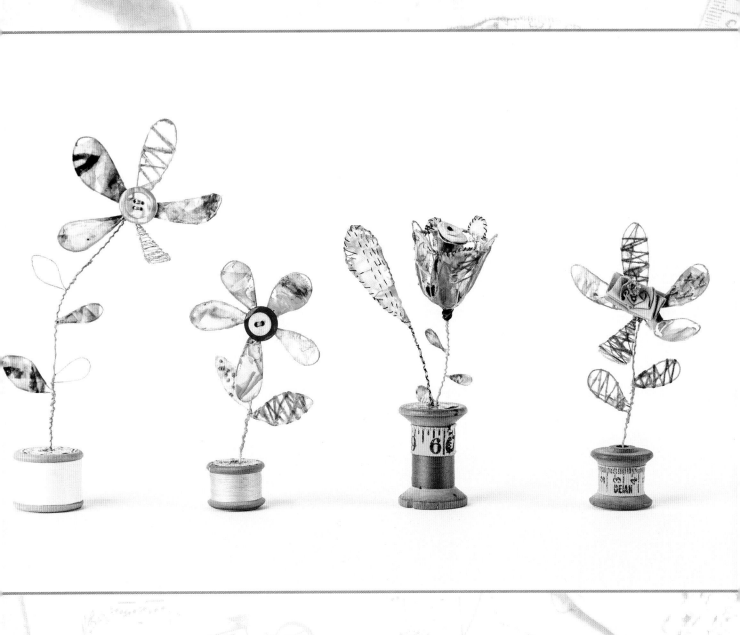

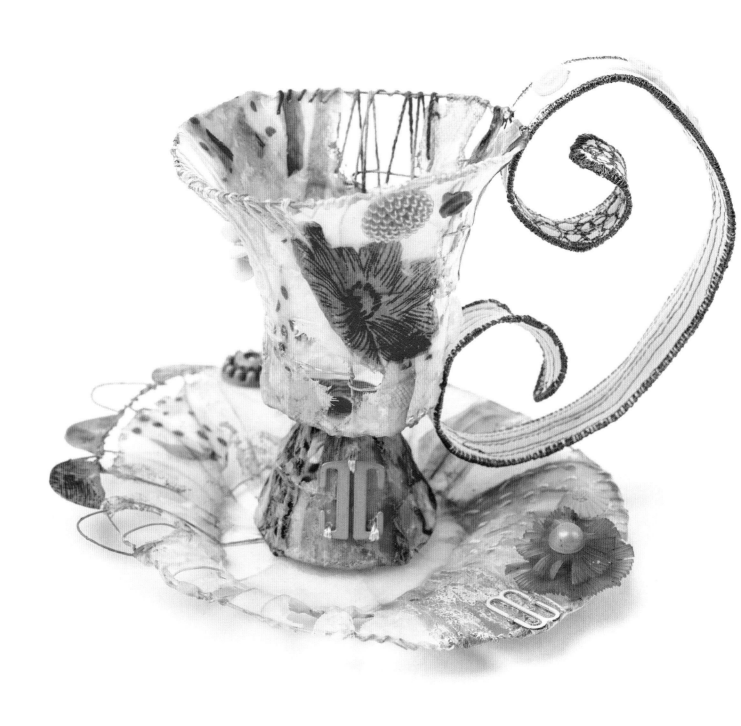

The finished piece
13 x 18cm (5 x 7in)

Time for Tea!

Making this teacup enables you to experiment with machine embroidery and incorporate it into a finished sculpture. This is a more complex project that brings together different components – cup top, cup base, saucer and handle – to make up the whole piece. It's exciting to bring these together at the end. This project also allows you to experiment more freely with different fabrics, as the surface area is larger than in previous projects. You can incorporate sections of patterned fabrics and add more concentrated areas of hand stitching.

YOU WILL NEED

Pack of 24 gauge wire in 36cm (14in) lengths

Pack of 26 gauge wire in 36cm (14in) lengths

Grip pliers

Wire cutters

A small selection of silks and lace in a range of contrasting colours and tones

Embroidery needles and threads, including hand-dyed thread

Fabric scissors and embroidery scissors

Wax, batik pot and old brush

Pins

Champagne cork cradle

Kid leather or other lightweight equivalent

Sewing machine and threads

1 Curl a length of 24 gauge wire into a circle 9cm (3½in) across, and join. Trim away the ends. Make a second circle measuring 5.5cm (2¼in) across from a second length of 24 gauge wire. Don't trim the end of this one, as we'll use this to attach the two together.

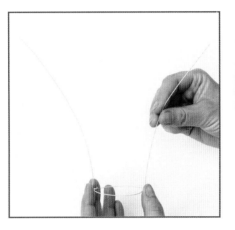

2 Use the grip pliers to bend the loose end of the smaller circle upwards at a right angle, then join a new length to the smaller circle, opposite the bent end. Gently flare out the upright lengths of wire, curving them outwards as shown.

TIP

Instead of trimming the ends, you can work them back into the structure – it's up to you.

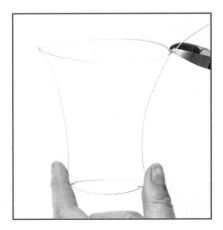

3 Join the larger circle on with the upright lengths, making the piece roughly 7.5cm (3in) high. Trim the ends.

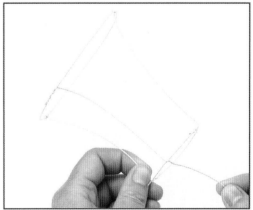

4 Join a new length of 24 gauge wire to the larger circle, halfway between the two uprights. Run it down to the small circle, matching the curve of the other uprights, before joining it at the base.

5 Bend the new wire here and run it across the small circle. Join it on the opposite side, then run it up between the two initial uprights and join. This completes the initial shape of the top part of the cup. Check that it can stand upright – if not, use your table as a tool, pressing the base of the cup down firmly on the table and adjusting the structure until it does stand up. Don't worry if the cup is a little wonky or irregular; that's part of the charm of the piece. The key thing is that it's starting to look a bit like a teacup.

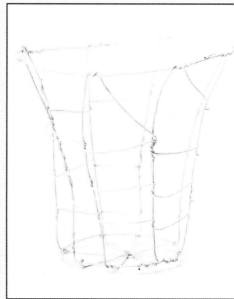

6 Add three more lengths of 24 gauge wire in the same way to build up a stronger frame. Space them evenly between the existing uprights.

7 Join on a 26 gauge length of wire to form the first cross support, working it around the cup and winding it around each upright in turn. As you work round, use your finger to ensure the cross supports are curved, rather than straight – otherwise you'll end up with a very angular cup!

8 Continue down the cup, adding three more lengths of 26 gauge wire. This will form a framework or underlying structure; aim for the gaps to be roughly 2cm (¾in) in size.

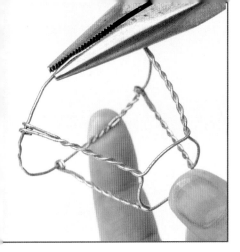

9 Use your grip pliers to round off the lower part of a champagne cradle.

TIP

You can, of course, make your own base from wire; but using a champagne cradle is a good way to upcycle waste – and the wire is a heavyweight gauge, which will help to make your cup stronger and better balanced.

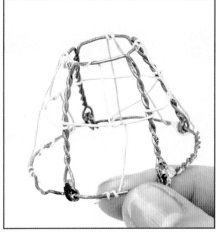

10 Use 26 gauge wire to add more uprights, exactly as for the top of the cup, then add cross supports with another length of 26 gauge wire to complete the base of the cup.

11 Using 24 gauge wire, make a circle 9cm (3½in) in diameter; and a second 12.5cm (5in) across. You will need to join two lengths together for the larger circle. Trim (or work in) the ends of the smaller one, but leave one longer end in place on the larger.

12 Use the longer end to join the two circles together, then join another length of wire on the opposite side to join the two circles here, too. Add a curve to start to raise the larger circle (the edge of the saucer) from the surface.

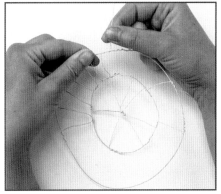

13 Add some supports across the small circle using lengths of 24 gauge wire, then join the edge of the saucer to the centre by winding 24 gauge wire all around.

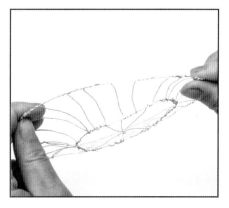

14 Once the wire has been twisted all the way round, ensure the saucer sits flat on the surface. Spend a little time ensuring the gentle curve between the edge and the base of the saucer is present.

15 Join a length of 26 gauge wire to the edge of the saucer and start to make small decorative loops around the outside.

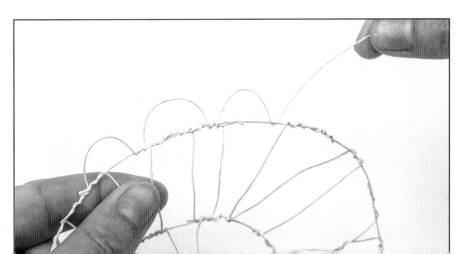

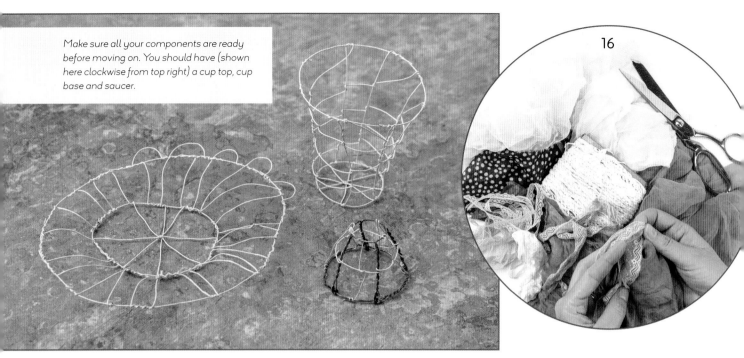

Make sure all your components are ready before moving on. You should have (shown here clockwise from top right) a cup top, cup base and saucer.

16

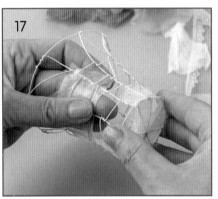

17

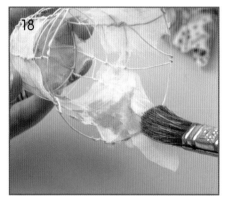

18

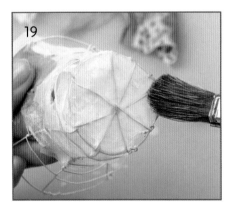

19

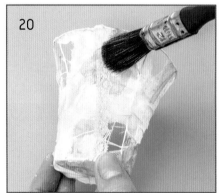

20

16 Set up your batik pot and, while it warms, select your fabrics. Once you have selected the fabrics you would like to use cut them into pieces approximately 3–4cm (1¼–1½in) square. You don't have to be to accurate here, this is just a guide. Your cut fabrics can be any shape; it's not necessary for them to be square.

17 Use the 12mm (½in) brush to apply wax to the fabric and begin to build up the surface on the upper part of the cup. Get your hand into the cup and use your fingers to encourage the waxed fabric to follow the curve of the wire once the wax has cooled slightly.

18 Apply fabric to the inside surface of the cup, too. Again, once the wax has cooled enough to touch, but before it has set entirely, use your fingers to encourage it into smooth curves.

19 We'll be stitching the bottom part of the cup to the fabric of the base, so it's important not to leave too many gaps in the fabric here. Feel free to have a few small gaps, but keep them to the edges.

20 Lace is openweave, and provides a contrast in texture. Apply a little to the upper part of the cup – we'll use more on the saucer later, but having a touch here will help to link the two parts.

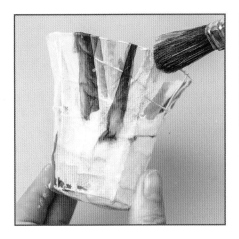

21 Tiny strips of fabric work well to overlap the lip of the cup: attach them initially to the inside, loop them over the top, and then brush them down on the outside, too.

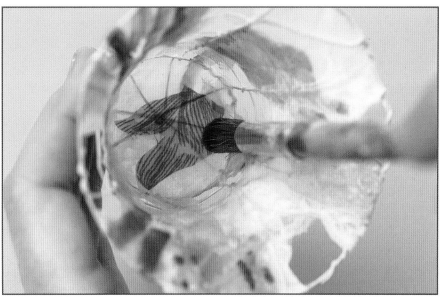

22 Once you are happy with the coverage over the cup top, you have the option of developing the pattern and interest with elements of printed fabrics. Use embroidery scissors to cut out an element of a printed fabric, then apply it with wax. As well as creating interest in themselves, these elements are great to develop further with stitch.

TIP

This is also a good way to hide or alter an area that you are unhappy with, for whatever reason, or to strengthen important areas like the inside at the bottom.

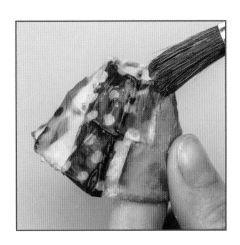

23 Cover the base of the cup in the same way, starting with fairly plain white silks. Note that you will need to leave the top open, as you'll need access to make stitching easier. Add some more decorative fabrics, and remember to leave a few small gaps.

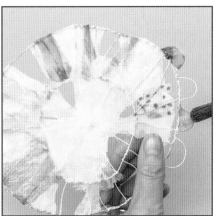

24 The saucer is a great place to use lace, but some plain white areas will help to balance the more striking colours and textures. Add the plain silks first, securing each piece with wax as you go and leaving small gaps. Add some pieces to the decorative loops, too.

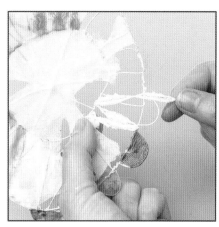

25 Thread a lace strip through a gap in the base of the saucer, securing one end with a dab of wax, before weaving it in and out of the wire structure between the two original circles (that is, the edge of the saucer's base and the rim). Secure the lace by painting wax over the areas in contact with the wire.

At this point, the components are all covered with fabric and ready to assemble and embellish.

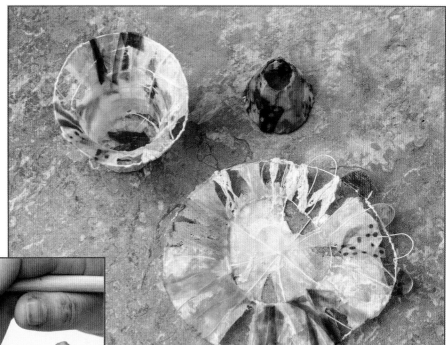

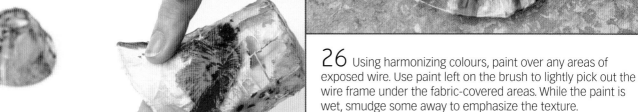

26 Using harmonizing colours, paint over any areas of exposed wire. Use paint left on the brush to lightly pick out the wire frame under the fabric-covered areas. While the paint is wet, smudge some away to emphasize the texture.

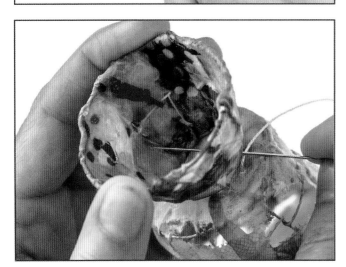

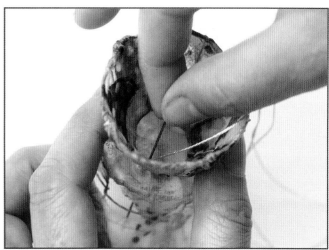

27 Place the cup top on the base, where you want it to sit. Thread a fairly long needle and knot the thread. Take it into the base of cup top, and through the fabric. Draw the thread through and take it through the side of the cup bottom, near where it came up.

28 Draw the thread through and take the needle back down through the fabric of the cup top, pinning the wire of the cup bottom to the fabric of the cup top. Continue working round to secure the cup top to the cup base. I make a stitch roughly every 5mm (¼in) or so.

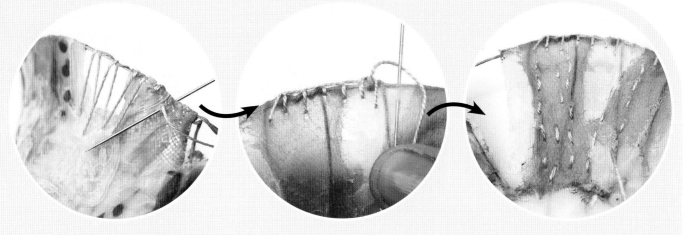

29 Add embroidery embellishments to the cup and saucer. I've started with bridging whip stitch over the lip (above left); buttonhole stitch over the edge of the saucer (above centre); and running stitch on the saucer (above right).

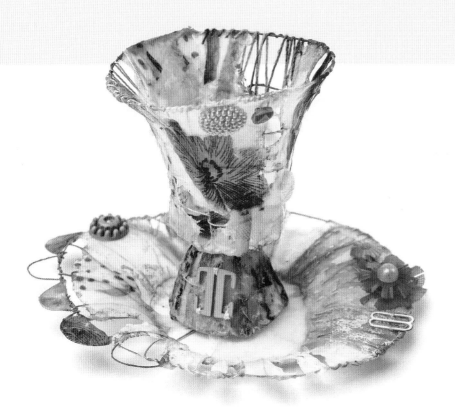

31 Now to make the handle. Use your fabric scissors to cut a 4cm (1½in) wide strip of leather measuring 35cm (13¾in) in length. Where possible, try to include a few points of interest – the buttons, buttonholes or stitching on this pair of vintage opera gloves will make for great design flourishes for my teacup.

30 Attach your other chosen embellishments, using thread where possible, and glue where not. Bear in mind that you will need space to attach the handle, so plan for that when choosing and placing your embellishments.

TIP

If you can't find an equivalent piece of clothing, then you can use any lightweight leather – or substitute a couple of layers of a fabric like calico – for the handle.

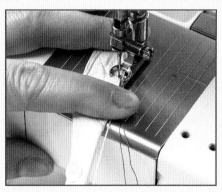

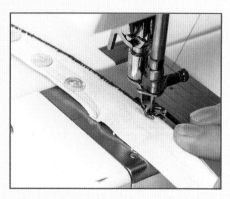

32 Fold the piece in half lengthways, and while it is doubled-up, trim the end into a curve. This will make things easier, as you won't have to stitch and handle corners. Repeat at the other end.

33 Set your sewing machine up for free machine embroidery (see page 56). Join two pieces of 26 gauge wire together and put them next to the doubled-up leather.

34 Working steadily, stitch down the length of the leather to secure the wire to it. Don't go too fast; you're working satin stitch, so avoid leaving gaps.

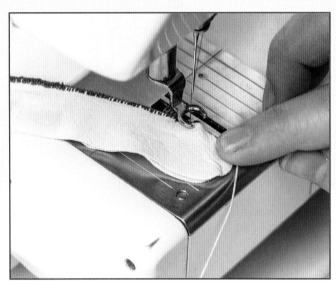

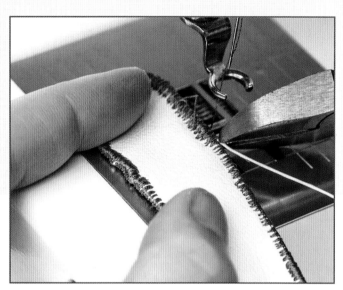

35 As you reach the end, curve the wire around to follow the line of the leather, and continue working round the shape. Take it particularly carefully and slowly round the curve, as it's easier to hit the wire here.

36 Continue stitching all the way round, as shown. When you reach the end, trim the wire with your wire cutters, then take it back under the foot and swap to straight stitch.

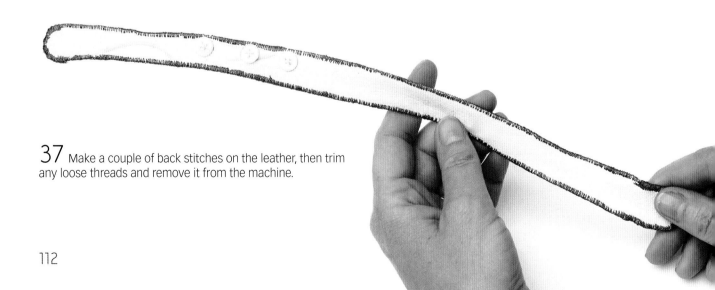

37 Make a couple of back stitches on the leather, then trim any loose threads and remove it from the machine.

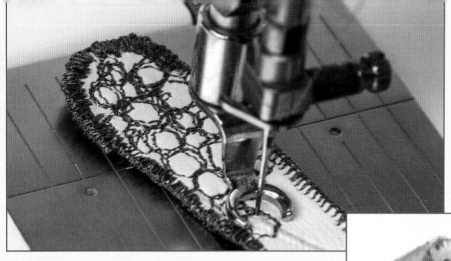

38 With the machine still set to straight stitch, use free machine embroidery to draw upon and decorate the handle with stitch. I'm making a series of small loops at one end.

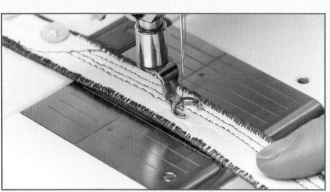

39 Add some longer lines, too. Finish with a little back stitch to secure the thread.

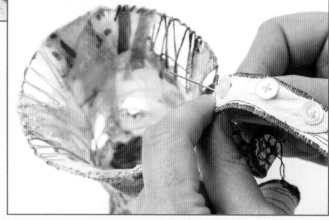

40 Curve the handle into shape and try out some placements on your cup. Once you've decided where you want it to sit, use stab stitch to secure it in place. Make sure you're working into fabric or around wire (or preferably both) to get a secure hold.

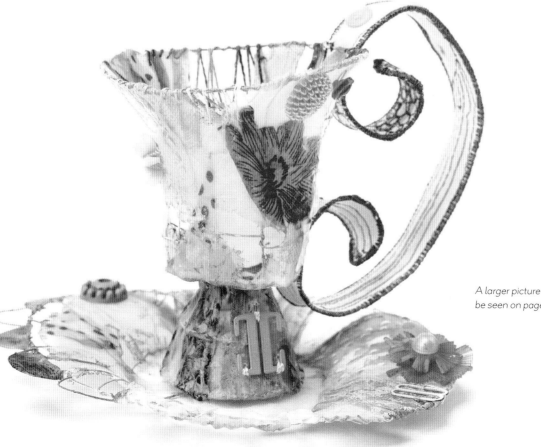

A larger picture of the finished project can be seen on page 104.

A Cup of Earl Grey

18.5 x 9cm (7³/₄ x 3¹/₂in)

This teacup is part of my Afternoon Tea collection. This quintessentially English theme is something I have referred to many times and is a subject of which I never tire. The collection was inspired by a visit to The Bowes Museum, which is a museum of art, fashion, and design in the north-east of the UK. They house a huge collection of ceramics from all different periods and it is a fantastic place to spend a day researching and sketching.

I wanted the focus of this cup to be the decorative edging so typical on tea cups from the Victorian period. I created a wire edging, and painted it in Wedgwood blue to reflect the colours of the time. The handle is made from gloving leather and decorated with machine embroidery. I made the foot of the cup from a piece of ceramic and decorated it with a dusty pink stitch in a stretched diagonal pattern to add that element of extra decoration.

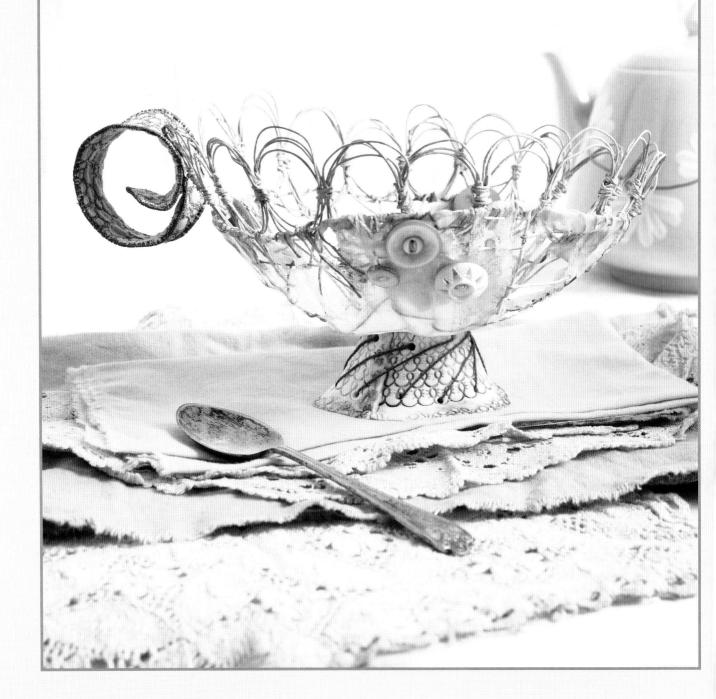

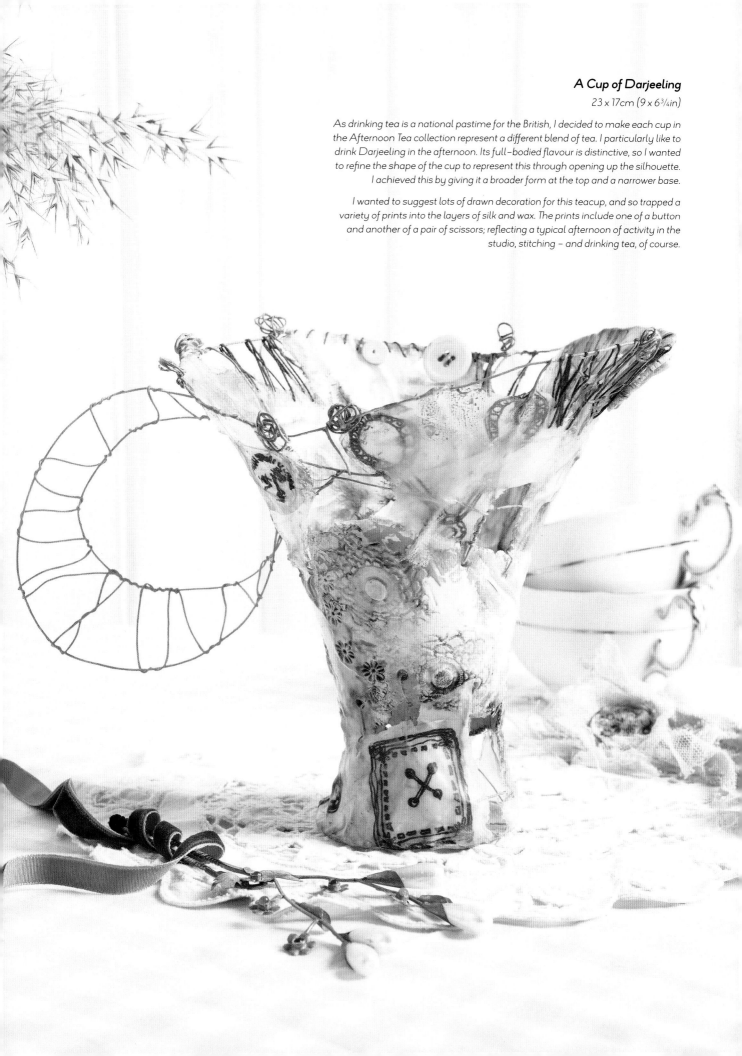

A Cup of Darjeeling

23 x 17cm (9 x 6¾in)

As drinking tea is a national pastime for the British, I decided to make each cup in the Afternoon Tea collection represent a different blend of tea. I particularly like to drink Darjeeling in the afternoon. Its full–bodied flavour is distinctive, so I wanted to refine the shape of the cup to represent this through opening up the silhouette. I achieved this by giving it a broader form at the top and a narrower base.

I wanted to suggest lots of drawn decoration for this teacup, and so trapped a variety of prints into the layers of silk and wax. The prints include one of a button and another of a pair of scissors; reflecting a typical afternoon of activity in the studio, stitching – and drinking tea, of course.

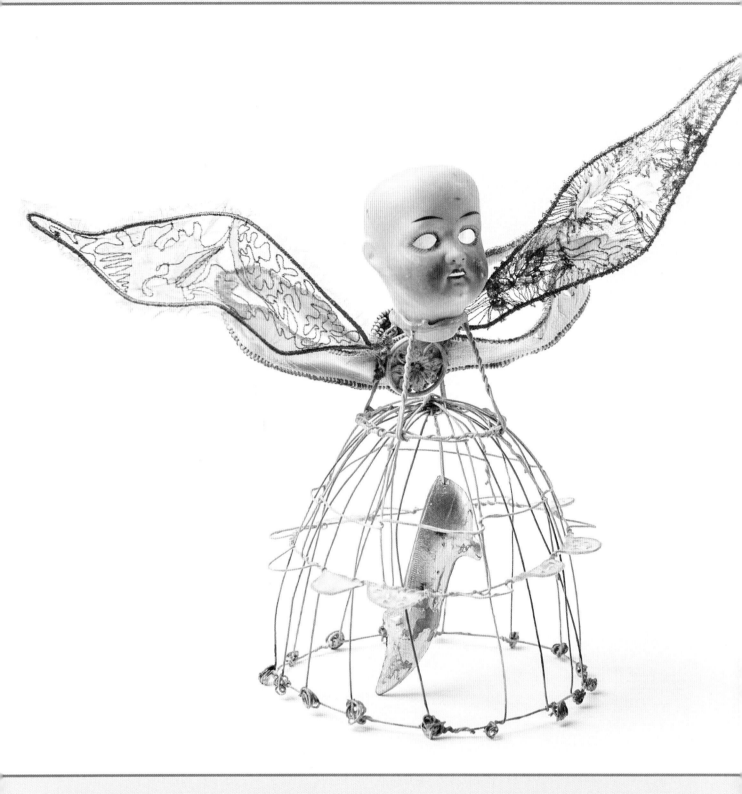

The finished piece

18 x 23cm (7 x 9in)

*If you have a particular doll's head that you wish to use, make this your starting
point when thinking about the structure of the piece. It's best to make the body and
wings to fit the scale of your doll's head.*

Angel Delight

This final project brings together all the techniques that you have explored so far and introduces a couple of new ones. Many years ago I discovered a dissolvable fabric product called Aquafilm – it changed my world! It allows you to stitch freely into the film before washing it away to reveal your very own stitched fabric. What could be more exciting? It's the perfect product to use with wire, because you can make a shape then stitch around and over the wire to create embroideries that can then be shaped into a three-dimensional form.

This project also shows you how to incorporate a ceramic head into the sculpture, making it a truly unique character. If you don't have an old ceramic doll's head you could use a plastic one, or even make a head out of fabric yourself.

YOU WILL NEED

- Pack of 24 gauge wire in 36cm (14in) lengths
- Pack of 26 gauge wire in 36cm (14in) lengths
- Grip pliers
- Wire cutters
- A small selection of prepared silks in a range of contrasting colours and tones
- Embroidery needles and threads
- Fabric scissors and embroidery scissors
- Wax, batik pot and 12mm (½in) brush
- Dusty pink emulsion paint and brush
- White, yellow and red acrylic craft paint
- Quink ink
- Pins
- Embroidery hoop
- Dissolvable fabric
- Champagne cork cradle
- Vintage doll head
- Sewing machine and threads
- Kid leather or equivalent
- Superglue and hot glue gun
- Gold powder paint
- Embellishments and small trinkets

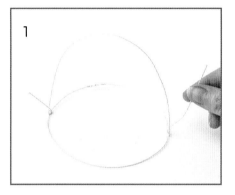

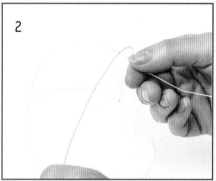

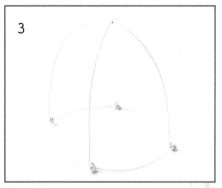

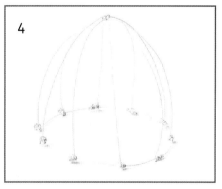

TIP

If your bobbles are too small, join on an extra length of wire, twist until the ball is the right size, then trim any excess.

1 Start by curling a length of 24 gauge wire into a circle 11cm (4¼in) across, and join. Use the grip pliers to crimp the join then trim away the ends. Join another length of 24 gauge wire to the circle, bend it into a hoop that stands 10cm (4in) high, then join it at the other end.

2 Join another length of 24 gauge wire to the circle as shown, then bend it over and attach it to the top of the hoop.

3 Attach the end to the other side of the circle to make a dome shape. Grip the ends of each wire with the pliers in turn and twist each to create little balls of coiled wire.

4 Join another six lengths of wire in the same way, adding them at evenly spaced distances between the existing wires to build up the structure.

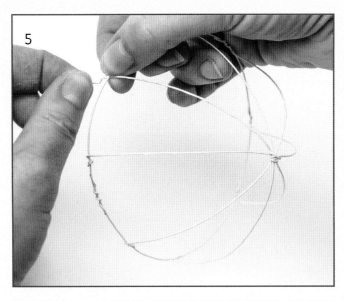

5 Make another dome with a base circle of 12cm (4¾in) diameter, joining the wires onto the base rather than making bobbles.

6 Build up a framework around the smaller dome using lengths of 26 gauge wire. Leave gaps of roughly 2.5cm (1in) between the lengths.

7 Join a length of 26 gauge wire to the edge of the smaller dome and make small decorative loops around the outside.

8 Use your grip pliers to reshape the bottom of the champagne cradle into a circle, then join a length of 26 gauge wire to the bottom of the champagne cradle.

9 Place the champagne cradle on top of the smaller dome and use the wire to join the two together.

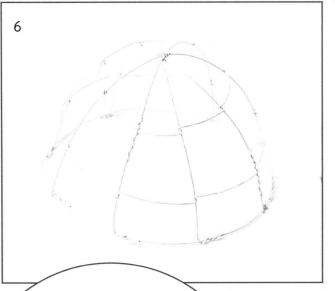

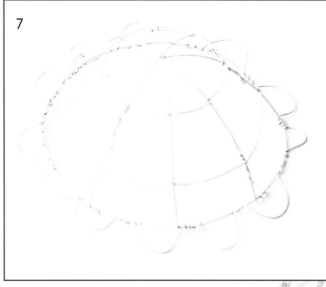

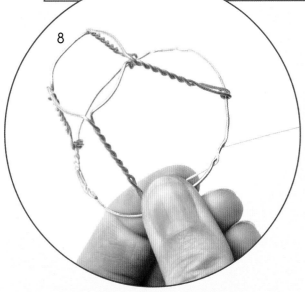

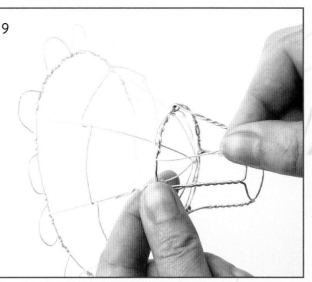

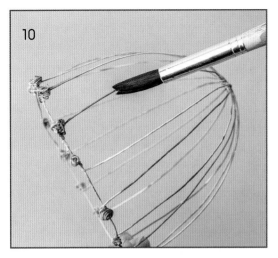

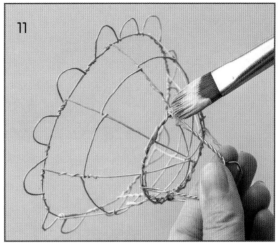

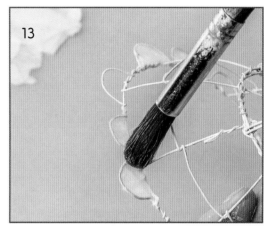

10 Protect your surface with a waterproof layer then use the emulsion paint to paint the taller dome. Once the emulsion has dried, water down your Quink ink a little then touch it on here and there over the dome to create a varied and distressed finish.

11 Mix the white, yellow and red acrylic paints to make a peachy colour, and paint the smaller dome and champagne cradle. Allow to dry.

12 Set up your batik pot and, while it warms, cut the fabric into small pieces.

13 Use the 12mm (½in) brush to apply wax to the fabric and secure it on the decorative hoops on the smaller dome.

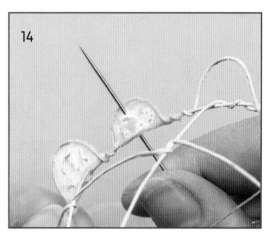

14 Thread a needle with contrasting thread and work seed stitch on the fabric.

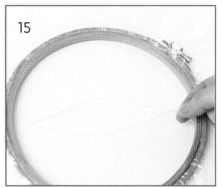

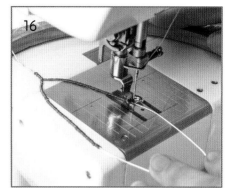

15 Secure a piece of dissolvable fabric in your embroidery frame, making sure that the front of the fabric sits at the back of the frame (see also page 58). Prepare a feather shape (see page 30) using a piece of 26 gauge wire and position it in the hoop.

16 Set your sewing machine up for free machine embroidery (see page 56) and use zigzag stitch to secure the wire feather frame to the dissolvable fabric.

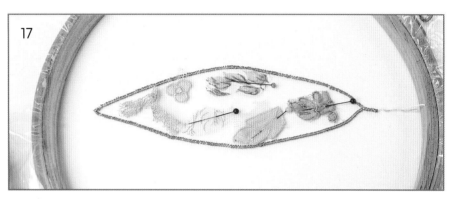

17 Remove the hoop from the machine. Cut a few small pieces of fabric and arrange them within the feather-shaped frame, leaving gaps between them. Use pins to secure them in place.

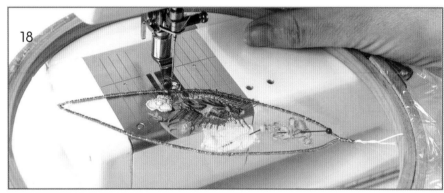

18 Place the hoop back in the machine and use a straight stitch to work back and forth over the whole shape. Be careful to work over the wire, and catch the edges of the fabrics, too. Keep your stitching relatively close together; once the dissolvable fabric is washed away, only the stitching will hold it together.

19 Continue building up the free machine work, removing the pins as you secure individual pieces of fabric. It's important that you strike a balance between an open lacy effect and making sure enough stitching is present to hold things together.

20 When you're happy with the stitching and your shapes are secure, remove the hoop from the machine. Cut away the excess dissolvable fabric, then rinse it away according to the instructions on the packet.

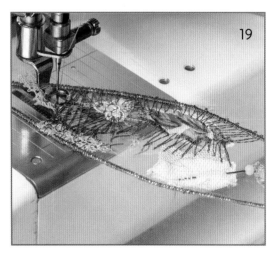

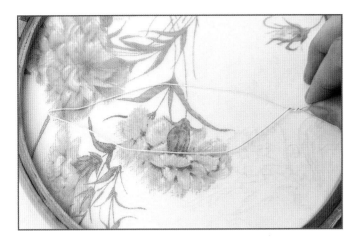

21 Secure a piece of patterned fabric in your embroidery frame in the same way as the dissolvable fabric earlier, then make another feather shape from a length of 26 gauge wire. Position this within the frame to take in some of the pattern from the fabric.

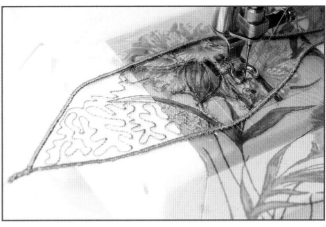

22 Work zigzag stitch round the outline, then add free machine embroidery over the inside surface. I've added some vermicelli (wandering lines) in an empty area.

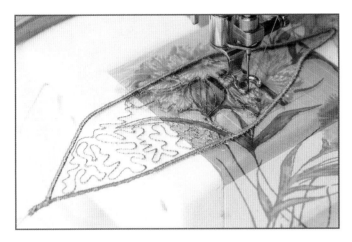

23 I highlighted the fabric design by reinforcing the outline with stitch; you will need to adapt this step to the printed design on your fabric.

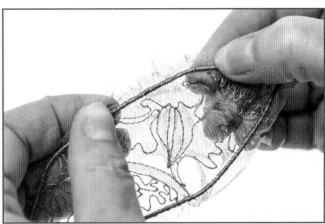

24 Cut out the feather shape, leaving a small border. Use your finger to gently fray it, leaving a fine fringe.

25 Gently bend both large feather-shaped wings into a more organic shape.

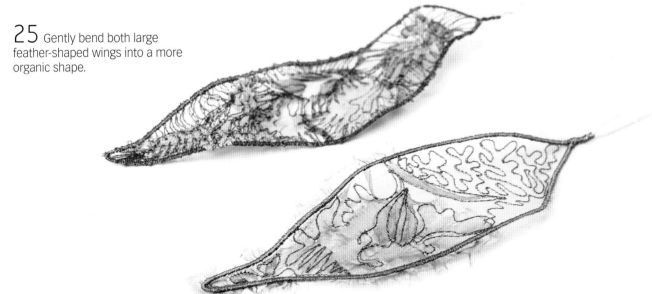

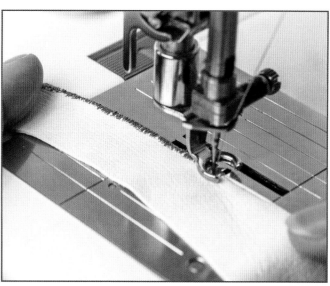

26 Cut a 38cm (15in) long and 2.5cm (1in) wide strip of kid leather. Round off the ends of the strip.

27 Join two lengths of 26 gauge wire, place them alongside the strip of leather and place them on your machine. Work zigzag stitch over the wire to secure it to the leather.

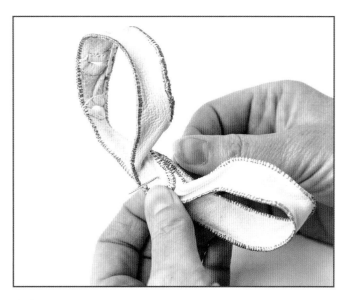

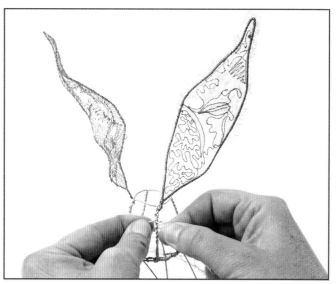

28 Work carefully around the curves at each end, then remove the piece from the machine. Trim the threads and bend the wired strip into a figure-of-eight, with the ends pinched together as shown. Thread a needle and add a few backstitches to secure the centre and complete the bow.

29 Use the ends of the wires to join the large wings to the champagne cradle.

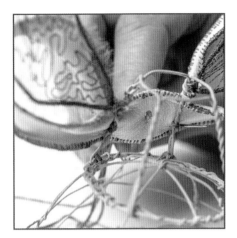

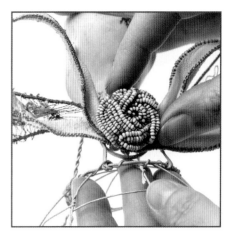

30 Thread a needle with coordinating embroidery thread, and attach the bow to each upright wire of the champagne cradle with a couple of whip stitches.

31 Use a hot glue gun to attach the vintage doll's head to the assembled body. Sprinkle a little gold powder paint onto the hot glue before it cools and sets.

32 Use superglue to attach a large embellishment in the centre of the bow at the front and at the back. I used a button.

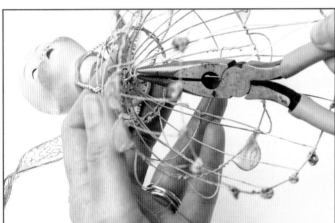

33 Using a length of 26 gauge wire, attach the assembled body to the taller dome – the crinoline skirt. Use your pliers to reach in and twist the wires to secure the piece. Do not trim the excess.

34 Use the remaining length of wire to secure a small trinket, like this shoe wedding favour, within the crinoline skirt to finish.

A larger picture of the finished project can be seen on page 116.

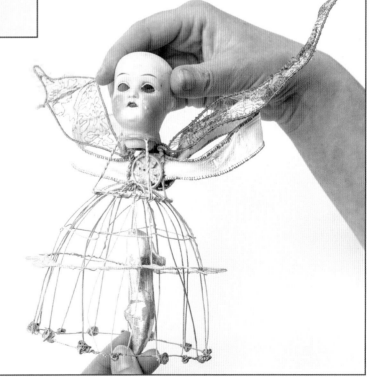

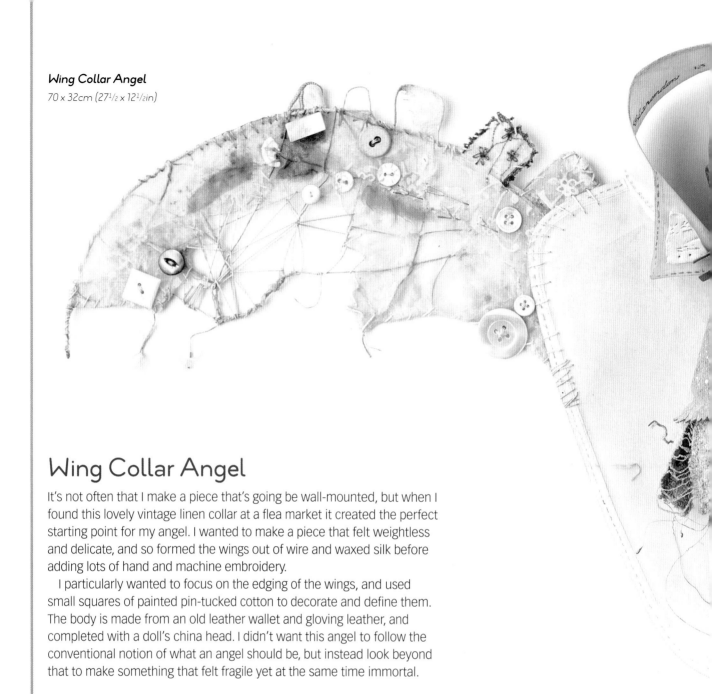

Wing Collar Angel

It's not often that I make a piece that's going be wall-mounted, but when I found this lovely vintage linen collar at a flea market it created the perfect starting point for my angel. I wanted to make a piece that felt weightless and delicate, and so formed the wings out of wire and waxed silk before adding lots of hand and machine embroidery.

I particularly wanted to focus on the edging of the wings, and used small squares of painted pin-tucked cotton to decorate and define them. The body is made from an old leather wallet and gloving leather, and completed with a doll's china head. I didn't want this angel to follow the conventional notion of what an angel should be, but instead look beyond that to make something that felt fragile yet at the same time immortal.

These details show how you can balance a delicate and ethereal overall look with complexity. The colours are carefully selected to be high–key and harmonious, tying in with the theme and heavenly concept.

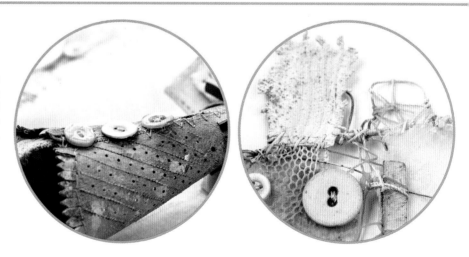

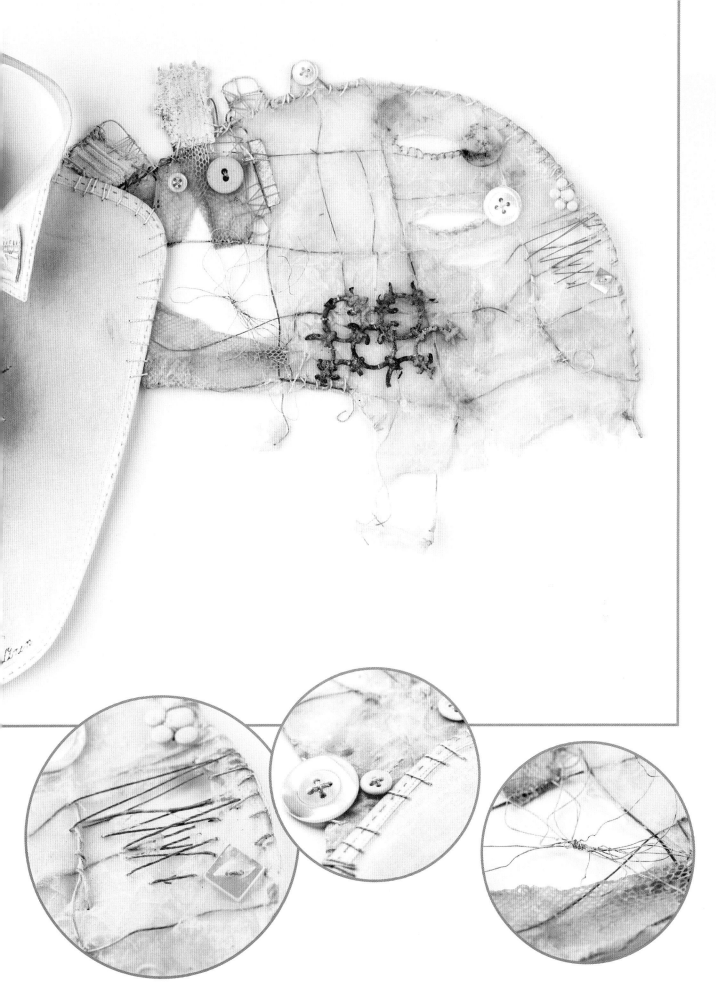

Moving on

This book has been written to inspire your imagination
and open up a new world of creative processes and
techniques. I've shared my own experience of working
with wire, fabric and wax to create sculptural forms
that communicate meaningful memories, emotions and
feelings in an original and personal way. My hope is
that you too can now do the same.

Throughout my creative journey I've discovered there
are no right or wrong ways of working, nor rules that can't
be broken. Just be intuitive in your making and sensitive
with your materials. As you move forward with your creative
voyage you will gain confidence and learn that you should trust
your instincts. These will lead you through the ebb and flow of your
own working practice. Always create what feels right for you.
Colour, fabric choices, scale and embroidery methods are the things that
will help bring originality to your pieces, so don't be afraid to take risks. They
may not always work, but you will learn from any mistakes you make along
the way. You may wish to introduce further techniques or add different
materials to your pieces. I thoroughly encourage this: be resourceful and
innovative. Challenge yourself to think outside the box.

I hope you have enjoyed making all the projects in this book as
much as I have enjoyed designing them for you. It's been a privilege
to share all my techniques and processes and I hope that you have
been encouraged to experiment and explore new ways
of working for yourself.

Keep enjoying the beauty of your own making
and see where it will take you next!

Let Your Wings Unfold

11 x 16cm (4¼ x 6¼in)

This piece is part of my Curious Creatures collection. I am always guided by the materials and when I sit down to make a new piece, selecting just the right ones is key to capturing the mood of a piece.

You should never have a clear idea of what you plan to make, only an outline: always let the materials take the lead. Let Your Wings Unfold is a perfect example of this. Allow the personality of a piece to develop naturally through the process of making and exploring – it is essential.

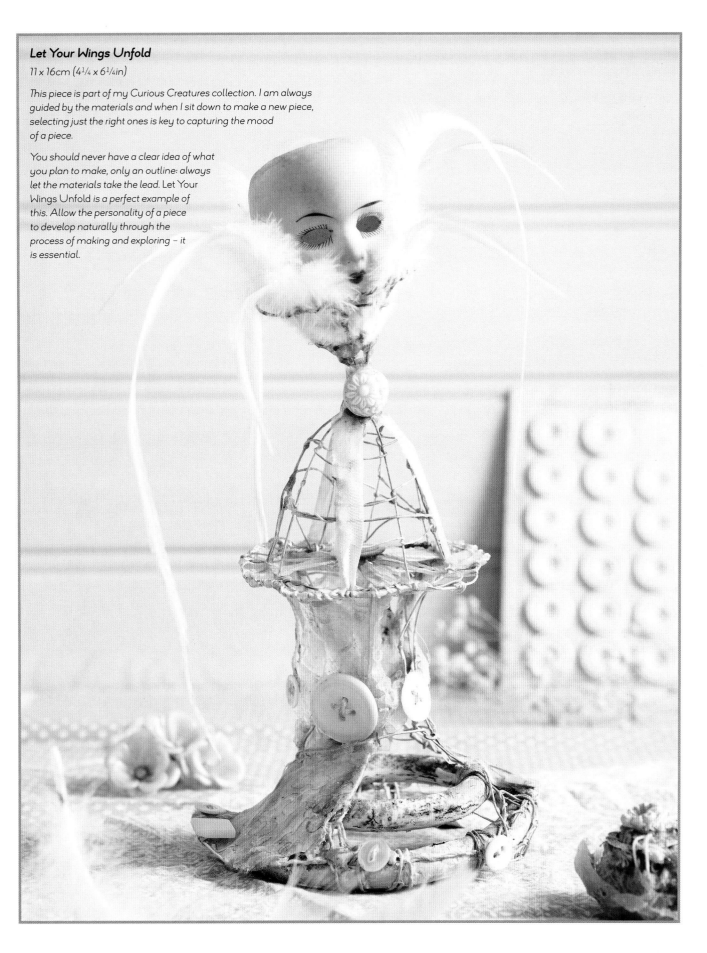

Index

Template for Fly Away Home on page 84

This template is provided at full size. Extra copies of the template are available from www.bookmarkedhub.com

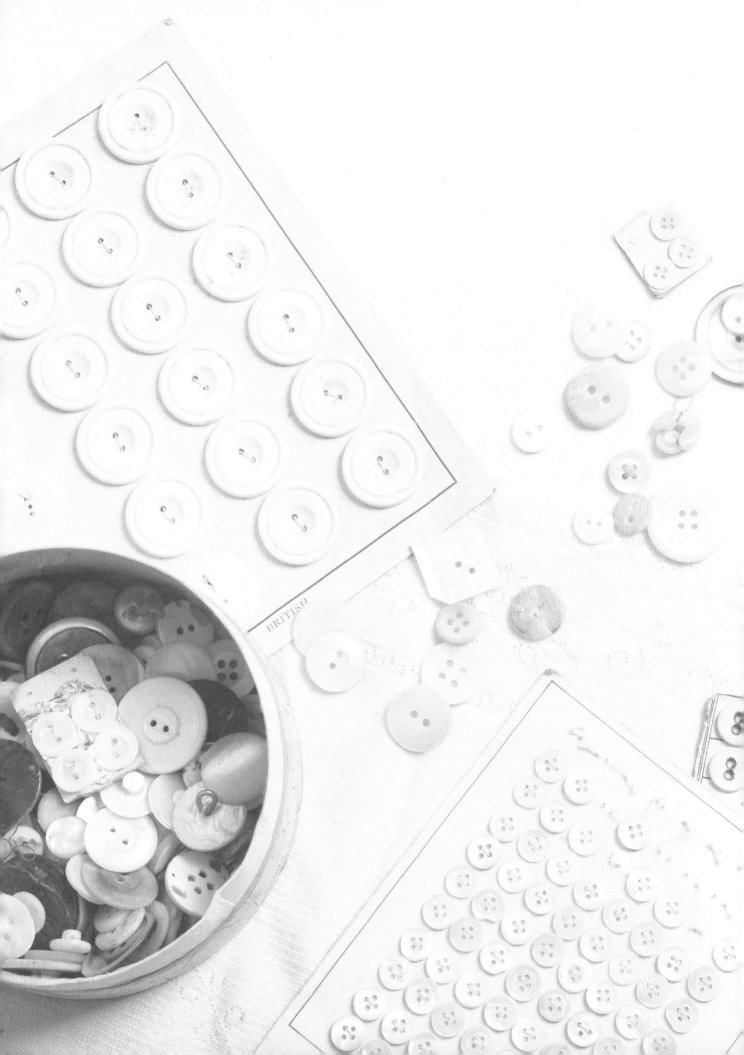